Lettering Tips

for artists, graphic designers, and calligraphers

Bill Gray

VAN NOSTRAND REINHOLD COMPANY
New York Cincinnati Toronto London Melbourne

To Tim and Jon, with love.

Library of Congress Catalog Card Number 79-18977

ISBN 0-442-26103-9

Published in 1980 by Van Nostrand Reinhold Company
A division of Litton Educational Publishing, Inc.
135 West 50th Street, New York, N.Y. 10020

Van Nostrand Reinhold Limited
1410 Birchmount Road, Scarborough, Ontario, M1P 2E7, Canada

Van Nostrand Reinhold Australia Pty. Limited
17 Queen Street, Mitcham, Victoria 3132, Australia

Van Nostrand Reinhold Company Limited
Molly Millars Lane, Wokingham, Berkshire, England

16 15 14 13 12 11 10 9 8 7 6 5 4 3 2 1

Library of Congress Cataloging in Publication Data

Gray, Bill.
 Lettering Tips

 Includes index
 1. Lettering. I. Title
NK3600.G78 745.6'197 79-18977
ISBN 0-442-26103-9

Contents

... the experience of creating something new or of uncovering some hidden beauty is one of the most intense joys that the human mind can experience.

H. E. Huntley

Introduction

The purpose of this book is to show how to form the major letter styles of the English alphabet. The styles are presented in chronological order from old-style Roman to date. Rules and dates are given but they are not rigid and absolute — they are given for guidance only. The book is not a showcase of the writer's lettering but rather a simple presentation of the information needed to form the letters correctly.

It is hoped that the book will be a primer — not in the sense of an elementary textbook but of a small charge that will ignite a much larger one. You are encouraged at all times to modify and change. As your proficiency improves, so will your enjoyment and excitement. Knowing what you are doing and how to do it and doing it well are noteworthy achievements. I hope to help you learn to letter well.

Understanding how to form beautiful letters is really quite simple. You need only to practice the tips given here, and in a short time you will experience the joy expressed in the quote at the top of this page.

The greatest thing in the world is the alphabet, as all wisdom is contained therein — except the understanding of putting it together.

From an old German bookplate

Foreword

If everyone in the world were to receive a paper marked with two points, A and B, and instructions to draw a line between them freehand, it is reasonable to say that no two lines would be exactly the same. On the other hand, if everyone were instructed to draw a straight line with the aid of a straightedge or other mechanical means, the lines might all be the same. These examples may be farfetched, but they demonstrate a point. Throughout this book freehand constructions of all letter styles are encouraged so that every stroke may be considered creative.

Your study starts at the beginning with the first alphabet — the classic Roman inscriptional letters — and continues from there. At all times personal interpretation and modification of the model styles, which in every case are considered by authorities to be the best, are encouraged. The interesting historical development of letter styles should be explored. Space does not permit an exhaustive account, but further investigation is advised and additional readings are suggested in the bibliography.

The Roots

Authorities believe that ancient Egyptian hieroglyphics were the distant ancestors of what is now called an alphabet. Egyptian hieroglyphics were a pictographic system of communicating information in terms of visual symbolism. It evolved into a written abstract form called hieratic script.

About 1000 B.C. the Semitic Phoenicians designed the first true phonetic rather than pictographic alphabet. It was probably greatly influenced by Egyptian hieratic script, and had no vowels. The Phoenicians were commercial seafarers, and their alphabet soon spread throughout the Mediterranean area. The Greeks adapted the Phoenician alphabet to fit their requirements. Vowels were added by 700 B.C. Later the Etruscans traveled from the Middle East through Greece and finally settled north of Rome. They probably brought with them the Greek alphabet. Shortly afterwards (200 or 300 B.C.) the Romans modified the alphabet to fit their needs, and the Latin Roman alphabet was created.

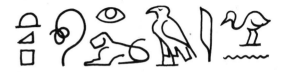

Egyptian hieroglyphics
4200 B.C.

Hieratic script
2500 B.C.

Phoenician
1000 B.C.

Early Greek
7th to 8th century B.C.

Early Latin Roman
1st century B.C. to 2nd century A.D.

Early Latin lettering on a gold brooch – 7th century B.C. It reads, from right to left, MANIOS MED SHEFHAKED NUMASIOI, "MANIOS MADE ME FOR NUMASIOI."

**Lapidary Roman capitals
1st century A.D.**

The 23 letters were called capitals. The small letters, which represented the capitals, were a much later development. These capital letters were inscribed in stone and became the classic Roman letters, the most beautiful of which are inscribed on the entablature at the base of the Trajan column in Rome (114 A.D.). They are the models for studying the first major style — the classic Roman capital.

```
SENATVSPOPVLVSQVEROMANVS
IMPCAESARIDIVINERVAEFNERVAE
TRAIANOAVGGERMDACICOPONTIF
MAXIMOTRIBPOTXVIIIMPVICOSVIPP
ADDECLARANDVMQVANTAEALTITVDINIS
MONSETLOCVSIANT  EIBVSSITEGESTVS
```

The Trajan column inscription 113-114 A.D.

	Phoenician 1000 B.C.	Greek 6ᵗʰ CENTURY B.C.	Early Latin 200 B.C.	Latin Roman Capitals		
				LAPIDARY (INCISED) 100 B.C. TO PRESENT	QUADRATA (PEN WRITTEN)	CURSIVE
A	⩇	⩜ ⋏	A	A	A	⋏ u
B	⏂ ꟼ ⊓	ᚱ B ⍴	B	B	B	B ℔
C	⟨	⟨ Γ	⟨ C	C	C	ℭ ℒ

Simplified chart showing the development of some of our letters.

Styles

Roman Capitals
1ST CENTURY B.C. TO 4th CENTURY A.D.

SENATVS
IMPCAESA
TRAIANO
MAXIMOT

Quadrata
1ST TO 4TH CENTURY

ABC
OPQ
RSTV

Rustic
1ST TO 6TH CENTURY

ABCDEF
GHIKLM
STVXYZ

Uncial
3RD TO 9TH CENTURY

ERATINCI
REFUSICA
IN REBUS
ALUTOBIS
HUMANIS

Semi-Uncial
CELTIC
5TH TO 8TH CENTURY

uia multa
ieaeba mul
tos aegros

ANGLO-SAXON
7TH TO 11TH CENTURY

natujiam quesup

Carolingian Minuscule
8TH CENTURY

abegr
hl mpt

Blackletter
12TH TO 16TH CENTURY

ABC
OPS
abcdefghi
stuvwxyz

Humanistic Bookhand
15TH AND 16TH CENTURY

the quick
brown fox
jumps over
the lazy
dog

Written Italic
16TH CENTURY

The nicest part
of Christmas
Is sharing it
with you —

Type

Prolariſq̃ uaſis
GUTENBERG – 1450
TEXTURA

gentium patr
NICHOLAS JENSON – 1470
EUSEBIUS OLD STYLE ROMAN

duo ru ptæ le
ALDUS – 1501
ITALIC

Garamond
1530

Caslon
1726

Baskerville
1757

Bodoni
1788

Square Serif
1825

Sans Serif
1898 – 1925

HUNDREDS OF VARIATIONS OF ALL OF THE ABOVE TO THE PRESENT.

Decorative Letters
FROM BEGINNING OF
MANUSCRIPT TO PRESENT

Formal Script
1722

*And hoping you
will always have
Much happiness
A B C abcdefghi*

Informal Script
ALL THROUGH HISTORY

*If all
DADS
were like you.*

Square Serif
1825

ABCDEF
MNOPQ
RSTUVW
abcdefghi
jklmnopq

Sans Serif
1898 – 1925 TO PRESENT DAY

abcdefghijk
lmnopqrstu
ABCDEFGH
JKLMNOPQ
RSTUVWX
123456789

Brush
FROM POMPEII TO PRESENT.
AS A STYLE FROM 1930'S TO
PRESENT

DAD

THANKSGIVING

Script

Contemporary

AUTOMATION

Palatino

Palatino Italic

Avant Garde

Antique OLIVE

Helvetica

AND MANY OTHERS

9

Parts of Letters

Shown here are the correct names for the parts of letters. You should use them to avoid confusion. They will be used throughout this book.

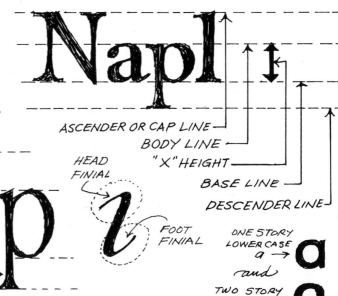

ASCENDER OR CAP LINE
BODY LINE
"X" HEIGHT
BASE LINE
DESCENDER LINE

HAIR-LINE
STEM
SERIF
CROSSBAR

ASCENDER
BODY
DESCENDER

HEAD FINIAL
FOOT FINIAL

ONE STORY LOWER CASE a →
and
TWO STORY LOWER CASE a →

a

a

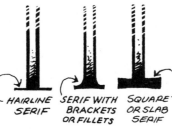

VERTICAL OR UPRIGHT LETTERS ARE ALSO CALLED ROMAN...

...AS COMPARED TO SLANTED, OR TILTED, LETTERS WHICH ARE CALLED ITALIC

HAIRLINE SERIF SERIF WITH BRACKETS OR FILLETS SQUARE OR SLAB SERIF

EAR
LINK
TERMINAL CURVE

✱ It is good practice to sketch letters with a pointed pen. The letters shown here were sketched with a technical pen.

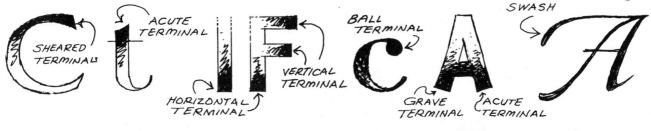

SHEARED TERMINAL
ACUTE TERMINAL
HORIZONTAL TERMINAL
VERTICAL TERMINAL
BALL TERMINAL
GRAVE TERMINAL
ACUTE TERMINAL
SWASH

REGULAR CONDENSED EXPANDED OR EXTENDED LIGHT FACE BOLD FACE REGULAR

SPLAYED

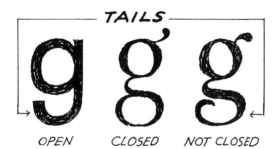

OPEN CLOSED NOT CLOSED

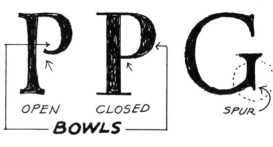

OPEN CLOSED
BOWLS

SPUR

ARMS

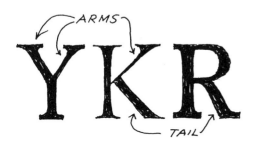

TAIL

ROUNDED POINTED HALLOW FLAT EXTENDED

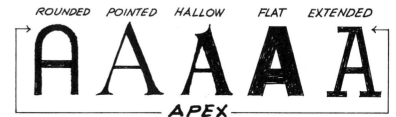

APEX

VOID COUNTER

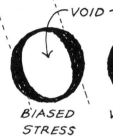
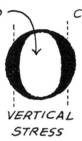
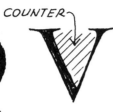

BIASED STRESS VERTICAL STRESS

UPPER LOOP

LOWER LOOP

HEAD

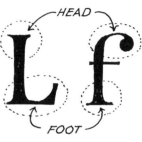

FOOT

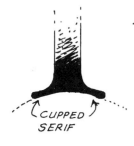

CUPPED SERIF

WEDGE OR BEAK ON ARM

SPINE

APEX

VERTEX

ARC OF THE STEM

CROSS STROKE

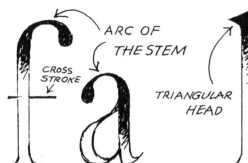

TRIANGULAR HEAD

HOOK OR BEAK

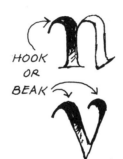

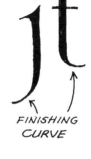

FINISHING CURVE

FLAGS

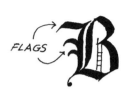

KERN

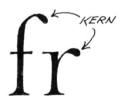

11

Glossary

Alphabet. *The letters used in a given language, 26 in the English.*

Calligraphy. *Elegant or beautiful writing.*

Happy Thanksgiving

Character. *A single letter image.* a

Chiselpoint. *Any tool (pen, pencil, brush) that has a flat edge like a chisel.*

Composition. *The actual setting of type.*

Cursive. *Written letters, usually joined and slanted.* Dear Dow: missed you at

Display. *Large letters used for emphasis — usually for a caption or heading.*

Em. *A printer's measure, the size of which is a square of the point size of the type.*

En. *A printer's measure equal to half an em measured from left to right.*

Expanded. *Letters extended from left to right and wider than the normal form.* A NORMAL A EXPANDED

Font. *The letters, numbers, and other marks comprising one type style.*

Foundry. *A manufacturer of type.*

Grotesk. *The European designation for sans-serif type or letters.*

AGHIJ ayz

Inline. *Letters with a line inside the form.*

INLINE

Italic. *Letters slanted to the right.* Abc

Justification. *The alignment of the left- and/or right-hand margins of two or more lines of letters or type.*

FLUSH LEFT FLUSH RIGHT FLUSH L. AND R.

Layout. *A rough or comprehensive plan showing the arrangement of all elements in a design.*

Ligature. *A combination of 2 or more letters that are joined together.* Œ æ

Machine set. *Type composition done mechanically on a machine.*

ABCDEFGHIJKLMN
OPQRRSTTUVWXYZ
Qu & . , - : ; ' ' " " ! ? [] ()

abcdefghijklmnop
qrstuvwxyz & ff fi fl ffi ffl
() [] . , - ' ' " " : ; ! ?

ABCDEFGHIJKLMN
OPQRSTUVWXYZ &
$ 1 2 3 4 5 6 7 8 9 0 . , -
$ 1 2 3 4 5 6 7 8 9 0 . , -

A FONT OF CLOISTER OLD STYLE

Majuscule. Large capital letterforms.

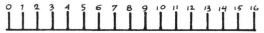
MNOP efghi

Measure. The width of one line of lettering or type.

Minuscule. Small letterforms. In type they are called lowercase.

Photostat. An inexpensive photographic print.

Pica. A type measure — ⅙ th inch or 12 points.

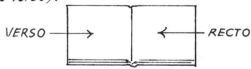

HERE ARE 16 PICAS. THERE ARE APPROXIMATELY 6 PICAS IN ONE INCH, AND 12 POINTS = 1 PICA

Point. A type measure — 1/72 inch or .013837 in.

Recto. The right-hand page of a book form (see verso).

VERSO → | ← RECTO

Roman. A letter style. It also denotes the upright position of a letter as compared to a slanted (italic) letter.

THICK AND THIN AND HAS SERIFS | T | UPRIGHT POSITION

Set. The relation or proportion of the width of a letter to its height. In type it also refers to composition (type-setting). Set-solid type has no leading between lines.

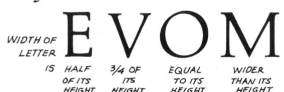
EVOM

WIDTH OF LETTER

IS HALF OF ITS HEIGHT | 3/4 OF ITS HEIGHT | EQUAL TO ITS HEIGHT | WIDER THAN ITS HEIGHT

Shaded letters. Letters that have a shadow effect.

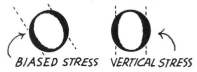
ACT

Slug. A line of type cast on one piece of metal, as on a linotype machine.

Specimen. An example of a typeface.

Stress. The weighted emphasis of curves found in Roman letters.

O O

BIASED STRESS VERTICAL STRESS

Style. The specific characteristics of a letterform.

Subhead. A subordinate heading or caption.

Text. Small letters in mass, as in the copy of a newspaper or book.

Typo. A colloquialism for a typographic ~~error~~ error.

Typography. The art of designing the most effective use of type for a given purpose.

Verso. The left-hand page of a book.

Visual. A very rough, small layout.

Weight. The boldness or thickness of a letter.

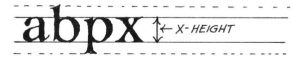
A A A A A

LIGHT MEDIUM SEMIBOLD BOLD EXTRABOLD

x-height. The height of the body of small or lowercase letters — it does not include ascenders or descenders.

abpx ↕ ← X-HEIGHT

Tools

The tools needed for creative lettering are relatively inexpensive and few in number. As your experience (and pocketbook) grows, you may want or need new materials. Increase your supply gradually. Most of your early work will be done with only a flat-edged tool, paper, pencils, and inks. For the rest of your lettering life you will always be looking for better pens, paper and inks — the search for new and better materials never ends.

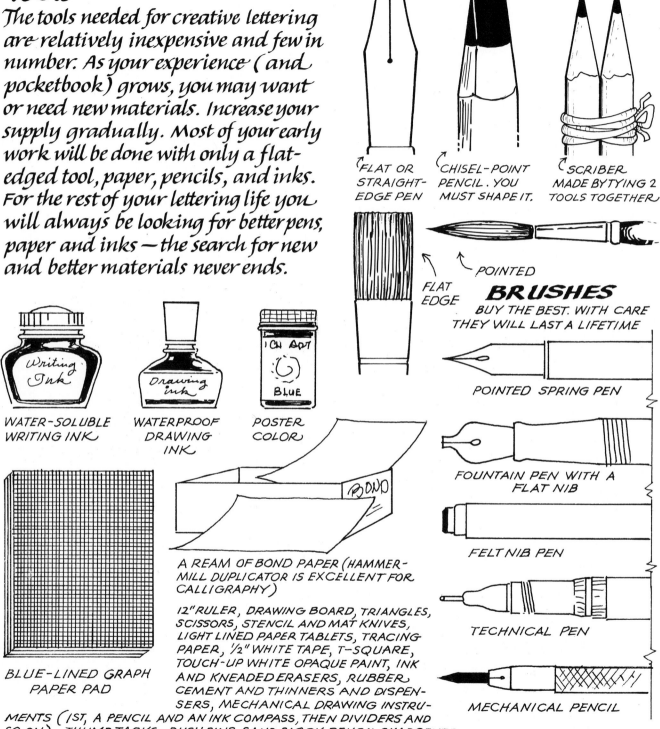

FLAT OR STRAIGHT-EDGE PEN

CHISEL-POINT PENCIL. YOU MUST SHAPE IT.

SCRIBER MADE BY TYING 2 TOOLS TOGETHER

FLAT EDGE

POINTED

BRUSHES
BUY THE BEST. WITH CARE THEY WILL LAST A LIFETIME

WATER-SOLUBLE WRITING INK

WATERPROOF DRAWING INK

POSTER COLOR

A REAM OF BOND PAPER (HAMMER-MILL DUPLICATOR IS EXCELLENT FOR CALLIGRAPHY)

12" RULER, DRAWING BOARD, TRIANGLES, SCISSORS, STENCIL AND MAT KNIVES, LIGHT LINED PAPER TABLETS, TRACING PAPER, 1/2" WHITE TAPE, T-SQUARE, TOUCH-UP WHITE OPAQUE PAINT, INK AND KNEADED ERASERS, RUBBER CEMENT AND THINNERS AND DISPENSERS, MECHANICAL DRAWING INSTRUMENTS (1ST, A PENCIL AND AN INK COMPASS, THEN DIVIDERS AND SO ON), THUMB TACKS, PUSH PINS, SAND BLOCK PENCIL SHARPENER, BLOTTING PAPER, WATER JUGS, RAGS, A PROPORTION WHEEL, FIXATIVE SPRAY CANS.

BLUE-LINED GRAPH PAPER PAD

POINTED SPRING PEN

FOUNTAIN PEN WITH A FLAT NIB

FELT NIB PEN

TECHNICAL PEN

MECHANICAL PENCIL

Writing, Lettering and Type

Before we design the styles, three classifications should be clarified.

May the gifts of love and warmth and happiness

Brush Script

DISCIPLINED WRITTEN ITALIC

YOUR OWN HANDWRITING

Formal Penmanship

Mom, Will be home late, Paula

1. Writing. When the forms are written directly with pen, pencil, brush, or other tool, they are called writing. They require little or no retouching.

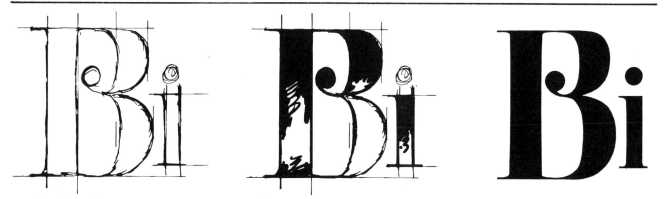

2. Lettering. Letters are carefully constructed with pencil, corrected, rendered in ink, and retouched with white paint if necessary.

Palatino Italic

Commercial Script

HELVETICA

Caslon

3. Type. A type letterform is first designed by lettering, then cast in metal or photographed for exact duplication when printed. Some photographic composition does, however, allow for for limited camera distortion.

Spacing

Letterspacing is an absolute requirement for all good lettering. With capitals a letterspace is the area of white space defined by the outside edges of adjacent letters and the top and bottom guidelines. All areas of white space between all letters of a word should be visually equal (although they may not be absolutely equal in size).

HO

HOME

Two adjacent strokes of vertical letters are separated by the greatest measured space. Two adjacent curved letters in the same word are the least measured distance apart.

H·I·N

O·O·C

The space is measured in the same manner for small letters except that the guidelines are the top and bottom of the <u>body</u>—not the ascenders or descenders.

thiper

Open letters require special treatment:

CEFLTSertz

The edges of letters with open sides (C, E, F, G, L, S, T, Z) can be estimated (for figuring letterspace) by the dotted lines in the example above. These edges are approximate eye evaluations and are not actually measured with a ruler.

IHVAIOCLAA

Suppose that the combination of letters on the top line composes a word. Most letterspacing problems that you will encounter occur in this example. If the areas between the letters (shown on the bottom line) are to be equal, all straight line combinations (IH, HV, VA, AI, and AA) would have the same measured distance between them. Measured in the middle, a curved letter would be closer to a straight letter (IO), and a curve would be still closer to a curve (OC). Open-sided letter combinations (LA) must appear equal to the other spaces by visual evaluation.

Word spacing is the area of white space between words. It can vary to fit words into a certain line width. Justifying the right-hand margin of continuous text is possible only by varying word spacing, never by letterspacing.

WOULD THAT WE COULD AT ONCE PAINT WITH THE EYES! IN THE LONG WAY FROM THE EYE THROUGH the arm to the pencil, how much is lost!

Line spacing is the space between lines, called leading (pronounced "ledding") in type composition.

IN THE ABOVE 3 LINES OF LOWER CASE LETTERS, THE SPACE IS MEASURED FROM ENDS OF ASCENDERS AND DESCENDERS – NOT FROM ALIGNING BASE LINES.

Would that we could at once paint with the eyes! In the long way from the eye through

THE ARM TO THE PENCIL, HOW MUCH IS LOST!

Flat-edge Tools

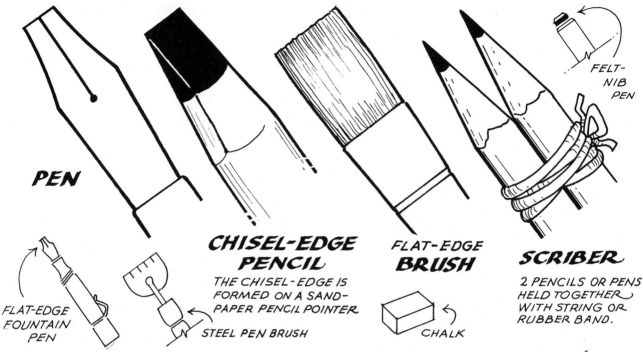

PEN

CHISEL-EDGE PENCIL
THE CHISEL-EDGE IS FORMED ON A SAND-PAPER PENCIL POINTER

FLAT-EDGE BRUSH

SCRIBER
2 PENCILS OR PENS HELD TOGETHER WITH STRING OR RUBBER BAND.

FELT-NIB PEN

FLAT-EDGE FOUNTAIN PEN

STEEL PEN BRUSH

CHALK

All the above are flat-edged tools. The use of the flat-edge tool in forming letters should be thoroughly understood. The tool forms the letters, as you will see with a little know-how and discipline. Shown here are some rules for forming many of the letter styles.

The pen is held so that the flat edge forms a certain angle with the base or aligning line. This position is called slanted pen, and the angle is called the pen angle. If the pen's edge forms no angle and the flat edge corresponds to the aligning line, the position is called straightedge.

The characteristics of each position are shown on the next page.

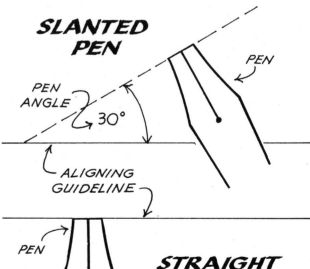

SLANTED PEN

PEN ANGLE

30°

PEN

ALIGNING GUIDELINE

PEN

STRAIGHT PEN

SLIGHT OR NO PEN ANGLE

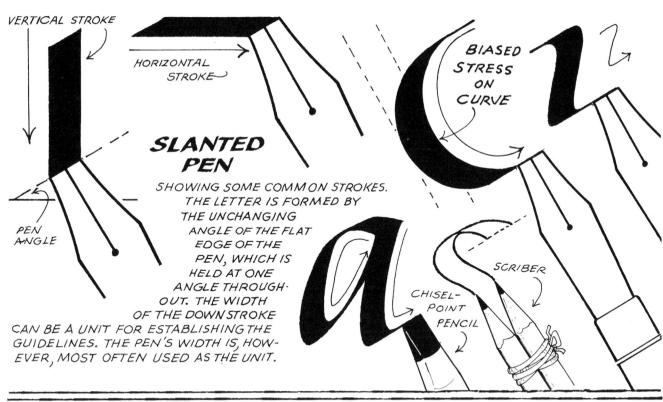

VERTICAL STROKE

HORIZONTAL STROKE

PEN ANGLE

BIASED STRESS ON CURVE

SLANTED PEN

SHOWING SOME COMMON STROKES. THE LETTER IS FORMED BY THE UNCHANGING ANGLE OF THE FLAT EDGE OF THE PEN, WHICH IS HELD AT ONE ANGLE THROUGHOUT. THE WIDTH OF THE DOWNSTROKE CAN BE A UNIT FOR ESTABLISHING THE GUIDELINES. THE PEN'S WIDTH IS, HOWEVER, MOST OFTEN USED AS THE UNIT.

CHISEL-POINT PENCIL

SCRIBER

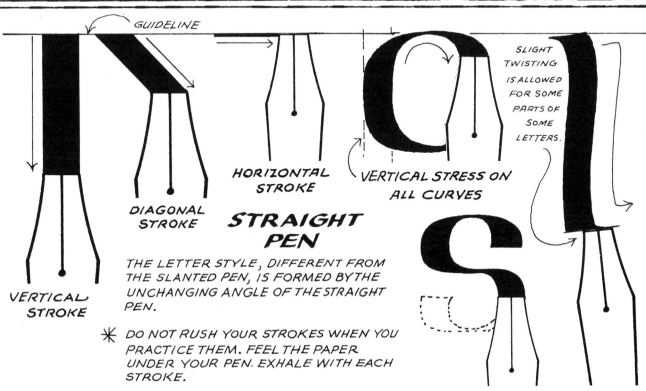

GUIDELINE

DIAGONAL STROKE

HORIZONTAL STROKE

VERTICAL STROKE

VERTICAL STRESS ON ALL CURVES

SLIGHT TWISTING IS ALLOWED FOR SOME PARTS OF SOME LETTERS.

STRAIGHT PEN

THE LETTER STYLE, DIFFERENT FROM THE SLANTED PEN, IS FORMED BY THE UNCHANGING ANGLE OF THE STRAIGHT PEN.

✻ DO NOT RUSH YOUR STROKES WHEN YOU PRACTICE THEM. FEEL THE PAPER UNDER YOUR PEN. EXHALE WITH EACH STROKE.

19

Oldstyle Roman Capitals

Shown on the opposite page are representations of the incised letters on the entablature at the base of the Trajan column (114 A.D.) in Rome. These classic old-style letters have been considered by authorities throughout the centuries as the most beautiful Roman capitals. They have been used by lettering designers as inspiration for the design of thousands of modified Roman capitals. I hope that they will do the same for you.

This alphabet is the mother of all styles. It has thick parts (stems, accents, reading parts), thin parts (hairlines, about half the thickness of the stem), and decorative parts (serifs) at the terminals of most strokes. The letter has a certain height in relation to the thickness of the stem (unit) — it is so many units high.

The most important relationship is the set — the width of the letter to its height. Some letters are wide, some narrow, and some in between. These sets must be memorized and used to relate the letters of the alphabets that you will create. As with any classic form, too much modification will result in a new style that is no longer old-style Roman.

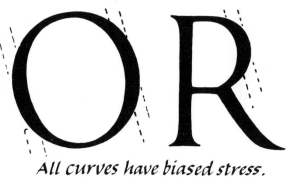

All curves have biased stress.

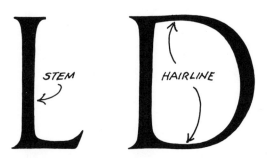

STEM

HAIRLINE

Hairlines are about ½ the thickness of stems.

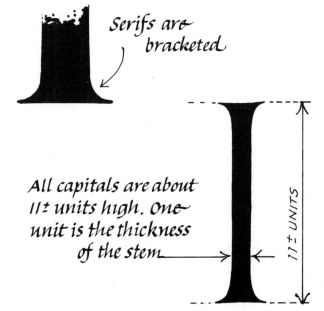

Serifs are bracketed

All capitals are about 11± units high. One unit is the thickness of the stem

11± UNITS

ABCDEF
GHIJKLM
NOPQR
STUVW
XYZ

The letters H, J, K, U, W, Y and Z, marked with a +sign, did not appear on the Trajan column. They are drawn here in the same fashion as the other letters to complete the alphabet. The letters J, U and W did not exist at this time.

21

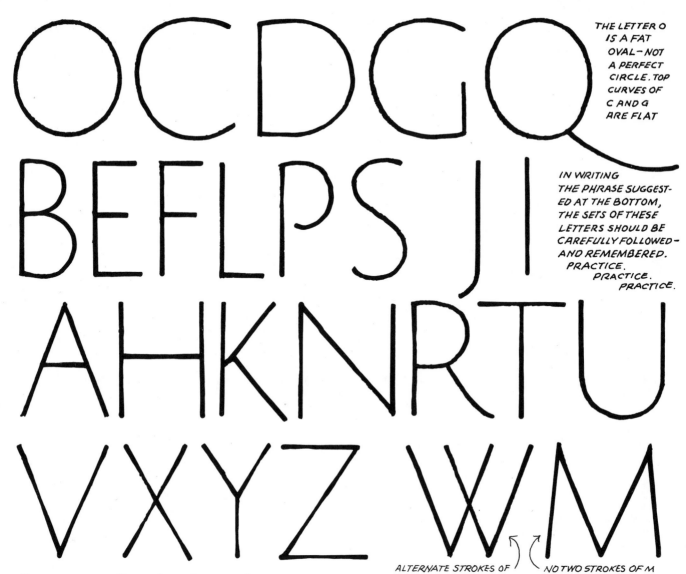

THE LETTER O IS A FAT OVAL — NOT A PERFECT CIRCLE. TOP CURVES OF C AND G ARE FLAT

IN WRITING THE PHRASE SUGGESTED AT THE BOTTOM, THE SETS OF THESE LETTERS SHOULD BE CAREFULLY FOLLOWED — AND REMEMBERED. PRACTICE. PRACTICE. PRACTICE.

ALTERNATE STROKES OF W ARE PARALLEL.

NO TWO STROKES OF M ARE PARALLEL.

Roman Capital Skeletons

Here you see the same letters reduced to simple skeleton forms and grouped according to similar sets. These letters should be practiced with pointed pencil, magic marker, or other pointed tool by writing simple phrases such as "THE QUICK BROWN FOX JUMPS OVER THE LAZY DOG"

Draw the letters slowly and deliberately, spacing them as you draw. Remember that the letters B, E, F, J, L, P, S are half as wide as they are high; M and W are slightly wider than their height; O, C, D, G, Q are based on a circle; and the rest of the letters are about three-fourths as wide as their height.

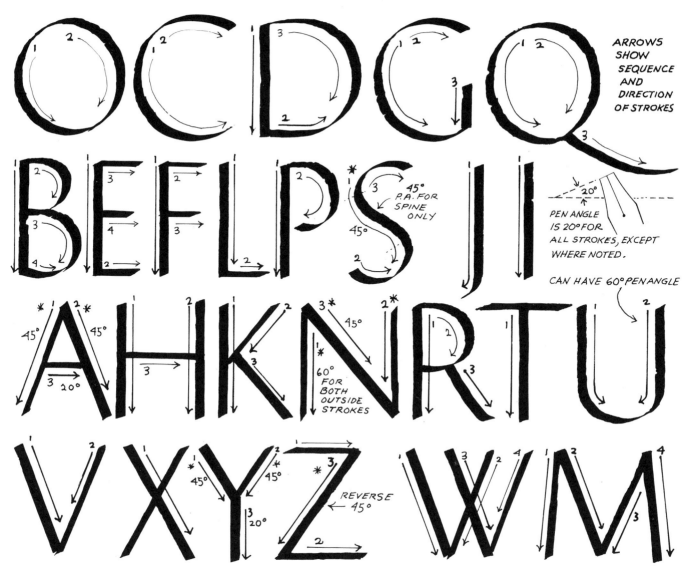

ARROWS SHOW SEQUENCE AND DIRECTION OF STROKES

PEN ANGLE IS 20° FOR ALL STROKES, EXCEPT WHERE NOTED.

CAN HAVE 60° PEN ANGLE

45° P.A. FOR SPINE ONLY

60° FOR BOTH OUTSIDE STROKES

REVERSE 45°

Roman Capital Structures

Practice the exercise on page 22 with a C-2 Speedball pen held at a pen angle of 15° to 20°. The pen angle changes for a few strokes, noted by an asterisk (*). Practice individual letters. Draw serifs by sketching them in with a pointed pen. Practice phrases as before and try spacing the letters as you proceed. Draw the letters large at first (about 1½" to 2" high).

THE QUICK BRO ETC.

SERIFS AND OTHER EMBELLISHMENTS CAN BE ADDED WITH A POINTED PEN.

23

Serifs

Serifs were added to Roman inscriptional letters as a finishing part for open-ended strokes. Aside from decoration serifs add to the legibility of the letters and also give them a horizontal alignment in words and phrases. Shown here are some of the many varieties of serif treatment. In creating your own Roman letter style pay particular attention to your serifs – they may help give your lettering a new look. Do not overornament them – keep them simple. Remember that old-style Roman lettering is conservative and dignified.

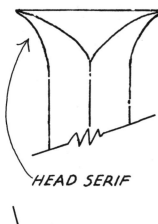

HEAD SERIF

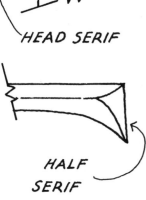

HALF SERIF

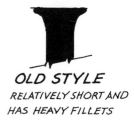

OLD STYLE
RELATIVELY SHORT AND HAS HEAVY FILLETS

MODERN
HAIRLINE AND HAS NO FILLETS

TRANSITIONAL
HAS SOME CHARACTER OF EACH OF THE ABOVE

NOLAN'S DEPARTMENT

Note how the serifs help to give horizontal alignment to the letters.

SERIFS ALSO SUGGEST ACCENTED TERMINALS IN OTHER STYLES

AE AE

CONDENSED LETTERS SHOULD HAVE SHORT SMALL SERIFS WHILE EXTENDED LETTERS CAN BE LONG.

HEAVY ROUND WITH FILLETS LONG POINTED SQUARE OR SLAB NO FILLETS SQUARE WITH FILLETS

TRIANGULAR CALLIGRAPHIC

HEADS OF ASCENDERS

CUPPED EXAGERATED FILLETS

DECORATIVE

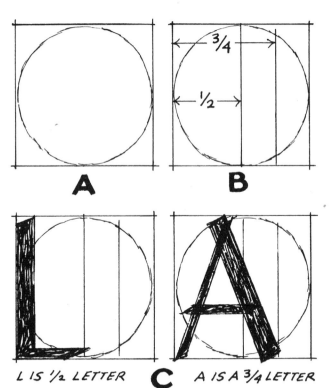

A B

L IS ½ LETTER C A IS A ¾ LETTER

GUIDELINE TRACING PAPER STRIP

← MOVE STRIP IN THIS DIRECTION AS YOU DEVELOP YOUR LETTERING

Tracing-paper Exercise

Here is an excellent exercise in relating Roman capitals to one another in a word or phrase and in letterspacing. Draw a square about 2" high and sketch a circle inside it (A). Divide the square into parts, as shown (B). Draw top and bottom guidelines to match your square on a separate piece of tracing paper. With a flat-edge tool held at an angle of 15° to 20°, develop your Roman capitals by moving the tracing paper over the diagram (B). Remember your letter proportions (which are half as wide as high, which are three-fourths, which are circular). Two typical letters are sketched for reference (C). Don't fret if your letters are not exactly proportional — it's not that important. Develop your word by moving the tracing paper across the diagram, (B), spacing the letters as you proceed. Add serifs later with a pointed tool. You should be very happy with the result when finished. You will use this same procedure later on for small letters.

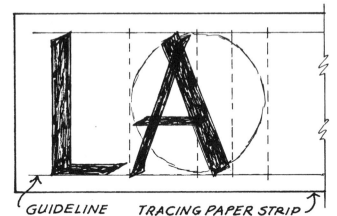

LAMBERTON

Add serifs and other refinements with pointed pencil or pen.

Old Style and Modern Roman

There are two major classifications of Roman letters — old style and modern.

Shown here are the main differences between the two.

OLD STYLE

MODERN

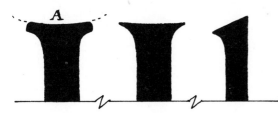

All curves have a biased stress. (dotted lines). Not a great contrast between stem and hairline.

Most curves have a vertical stress. Great contrast between stem and hairline.

Serifs are short with heavy fillets, or brackets. Some are cupped (A).

Most serifs are thin hairlines with no fillets. Some strokes have fillets at their terminals. Serifs on heads of lowercase letters are the same (A).

Terminals on some lowercase letters are like teardrops.

Terminals on some lowercase letters are circular.

Old style has a warm and friendly look. The letters should be completely drawn freehand. Weight changes are gradual.

Modern has a cold mechanical and impersonal look. Mechanical instruments may be used to draw them. Weight changes are sudden.

Quadrata and Rustica

Both Quadrata and Rustica are important in that they were intermediate developments between Roman capitals and other more significant styles still to come.

ABCDEFGHIJKLMN OPQRSTVWXYZ

Quadrata, or square capitals, are the first flat-pen written forms of Roman capitals. They were the book hands, or manuscript hands, of the 1st to the 4th century A.D. and were also used for important written documents. The letters are heavy and squarish and are formed with a pen angle of 15° or 20°. The capitals were used for a long time as initial headings.

ABCDEFGHIKLMNOPQRSTVXYZ

Rustica was used for manuscript writing in the 4th, 5th, and 6th centuries. It is very condensed, possibly to save space. It is based on Quadrata, but the letters are less formal and are written at a severe, nearly vertical, pen angle (60° to 90°). Some letters (E, F, A, N, P, R) require twisting the pen. It is a good alphabet with which to practice pen handling.

Shown above is a sample of the cursive capital writing prevalent at the same time as were Quadrata and Rustica. It was quickly written, scrawly everyday writing. FROM LEFT TO RIGHT THE ABOVE READS, "EGARETUR EXACTE CUTEX ANTENTI OS ECUNDUM OU..."

ABCDEFGHIJLM NOPQRSTUVY

Letters from the beautiful contemporary Balmoral, a typeface with an obvious Quadrata influence.

Uncial

Uncial is a straight-pen letter style that was developed by scribes in Italy around the 3rd and 4th centuries A.D. Missionaries visiting Rome took this style back to their homelands and made regional modifications. The letters were 1" high, hence the name "uncial." The letterforms were probably influenced by the cursive writing of the 1st century. The rounded forms are one of the most beautiful styles.

The letters are written here with a flat-edge tool (scriber) formed by attaching two pencils or marker pens. The points are almost parallel to the aligning line. Some letters require a slight twisting of the tool. You should become familiar with this scriber method because many other styles can be drawn in a similar fashion.

Some letters extend slightly above and below the guidelines. This effect marked the beginning of what later became small, minuscule, or (in the case of type) lowercase letters with ascenders and descenders. The letters are drawn three and a half pen widths high. Further practice with flat-edge chisel pencils, flat-edge pens (C-2), and flat-edge brushes is recommended.

ERAT INCIPIENS QUASI REFUSICAALUTOBISHE IN REBUS HUMANISPI

COPY OF EARLY MANUSCRIPT WRITING IN UNCIAL

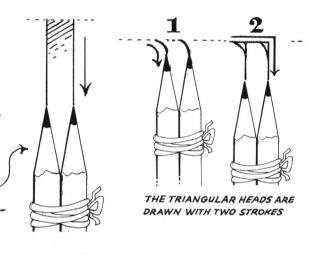

THE TRIANGULAR HEADS ARE DRAWN WITH TWO STROKES

THE LETTERS ARE FORMED BY THE ACTION OF THE FLAT EDGED TOOL HELD AT A CONSTANT ANGLE

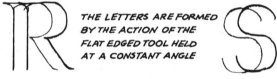

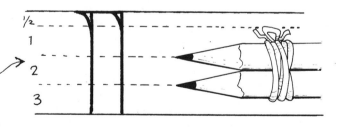

AMERICAN UNCIAL, A CONTEMPORARY TYPE FACE WITH OBVIOUS UNCIAL CHARACTERISTICS

GBRS abcdefghijklmnopqrstuvwxyz

28

ABCDE

FGHIJK

LMNOP

QRSTU

VWXYZ

Semiuncial

Around the 6th century the Uncial was modified into a smaller form called Semiuncial. The method of drawing it and its characteristics are the same as for the original uncial. Notable changes are the greater extensions of parts above and below the body of the letters. This led to the later development of ascenders and descenders as parts of small, or minuscule, letters. The letter is smaller than uncial, about ½", hence the name. As with writing uncial, the pen is held almost straight and the angle can change slightly for some parts, as shown in the model alphabet. The bottoms of some letters turn to join the next letter.

The Irish developed a beautiful form of this letter that is seen throughout Ireland. The beautiful Book of Kells is entirely written in Irish Semiuncial (shown here). Uncial and semiuncial are often referred to as Celtic alphabets. The semiuncial is sometimes referred to as demiuncial and halfuncial.

The scriber was used to demonstrate the alphabet on the opposite page because it shows all edges of strokes more clearly than the flat edge tool.

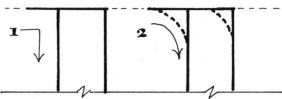

Semiuncial letters copied from The Book of Kells.

Triangular heads are drawn in the same manner as for Uncial.

Alternate letters

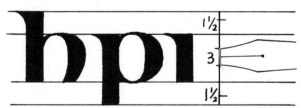

Letters are drawn 3 pen widths high. Ascenders and descenders are 1½ units high. These proportions are not absolute.

A FOOT SERIF CAN BE ADDED TO SOME LETTERS.

The letters shown above can join adjacent letters at the bottoms, as shown.

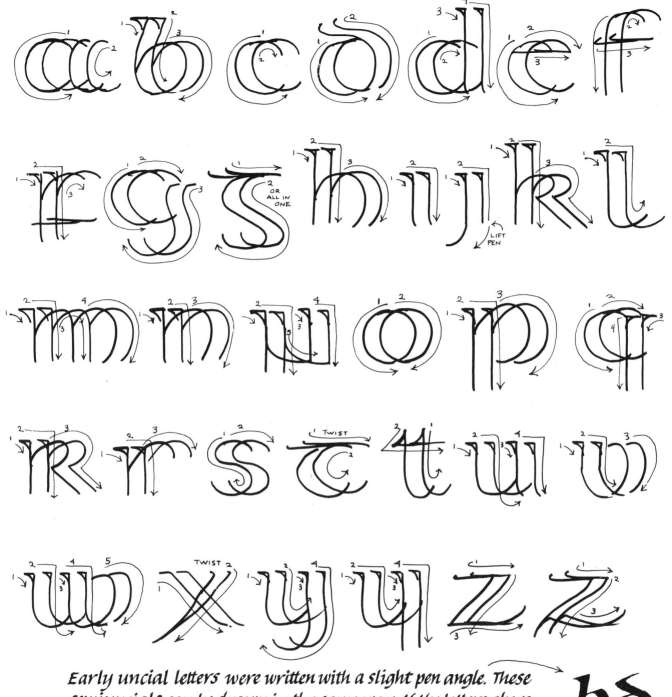

Early uncial letters were written with a slight pen angle. These semiuncials can be drawn in the same way. If the letters above were written with a flat pen, they would look like these

bd

abcdefghyklmno

Carolingian Minuscule

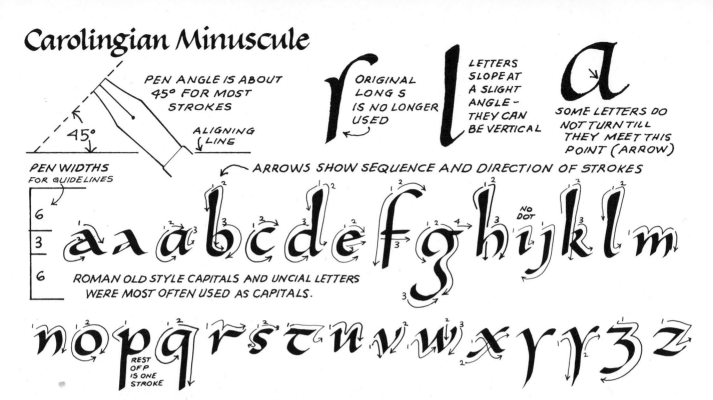

PEN ANGLE IS ABOUT 45° FOR MOST STROKES

ALIGNING LINE

45°

ORIGINAL LONG S IS NO LONGER USED

LETTERS SLOPE AT A SLIGHT ANGLE — THEY CAN BE VERTICAL

SOME LETTERS DO NOT TURN TILL THEY MEET THIS POINT (ARROW)

PEN WIDTHS FOR GUIDELINES

6 / 3 / 6

ARROWS SHOW SEQUENCE AND DIRECTION OF STROKES

a a a b c d e f g h i j k l m

ROMAN OLD STYLE CAPITALS AND UNCIAL LETTERS WERE MOST OFTEN USED AS CAPITALS.

NO DOT

n o p q r s t u v w x y y z z

REST OF P IS ONE STROKE

German tribes founded the Frankish Empire in western Europe, which in the 9th century evolved into the medieval kingdoms of France, Italy, and the Holy Roman Empire (Germany). Charlemagne, an early king of the Franks, had a style called Carolingian minuscule developed in order to simplify the confused state of manuscript writing, which had degenerated since the fall of Rome. This style was a part of his so-called revival of learning. Carolingian minuscule is shown above.

The evolution of Carolingian minuscule from cursive Roman uncial took place in the late 8th century. This beautiful letter had a tremendous influence on the development of later forms such as humanistic bookhand. Late Carolingian minuscule became more pointed and condensed and led to the development of Gothic black letters. During this period punctuation marks were devised.

The round forms were written with a slanted pen, and curves were compressed in the 13th, 14th, and 15th centuries to save space and paper. The forms became more and more condensed, pointed, and stiff. The Italians, however, maintained the round character, which led to the development of humanistic bookhand and (chancery-cursive) italic.

Gothic Black Letter

The Carolingian minuscule was adopted by the Germans around the end of the 12 th century. They changed the style into a heavy-stroked, condensed, angular letterform that looked black on the page. It resembled woven fabric and was called textura. The runic lettering of Scandinavia, which was also black and angular, may have had an influence on textura. Gothic black letter was used primarily for religious writing and the two are still associated today. It is also traditionally used for certificates, diplomas, wedding invitations, and newspaper mastheads.

Gutenberg's printing press arrived on the scene around 1450, and his famous 42-line Bible was printed in textura black letter. Schwabacher, rotunda, batarde, and fraktur were variations of black letter.

abcdefghimo

LATE CAROLINGIAN LETTERS

ΚΛPFRÞY

SCANDANAVIAN RUNIC LETTERS

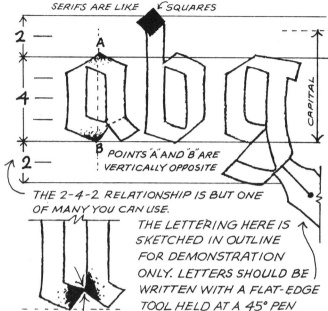

SERIFS ARE LIKE SQUARES

POINTS "A" AND "B" ARE VERTICALLY OPPOSITE

THE 2-4-2 RELATIONSHIP IS BUT ONE OF MANY YOU CAN USE.

THE LETTERING HERE IS SKETCHED IN OUTLINE FOR DEMONSTRATION ONLY. LETTERS SHOULD BE WRITTEN WITH A FLAT-EDGE TOOL HELD AT A 45° PEN ANGLE.

THE SECOND DOWN STROKE DOES NOT TURN TO THE RIGHT UNTIL IT REACHES THIS POINT (ARROWS).

COUNTERS AND SPACES BETWEEN LETTERS ARE VISUALLY ABOUT THE SAME AS THE THICKNESS OF THE STROKE.

"S" HAS A BROKEN SPINE

This is a basic textura minuscule alphabet – written here with a chisel-pointed pencil.

aabcdefghhijklmn
opqrsstuvwxyyz

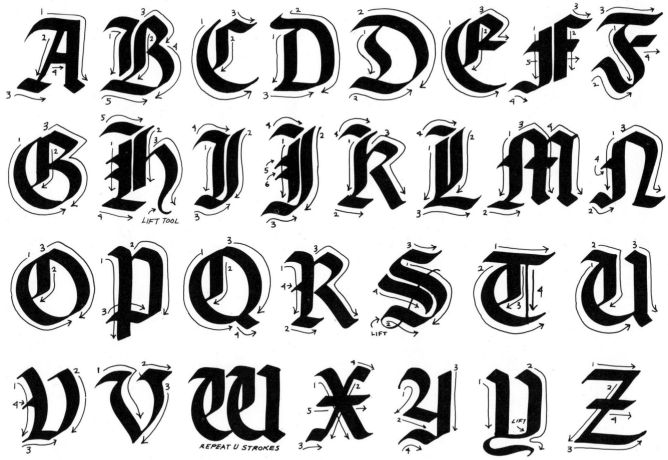

Merry Christmas

Black-letter caps at top and variations at the bottom. To the right are some of the major regional variations. To the left is an application appropriate for this black-letter style.

gothic textura
Batarde
Schwabacher
rotunda
Fraktur

aaaabbbccc

ddeefffggg

ghhhiiiiijjjk

kllmnnooppg

qrrssttuuv

vwwxxyyzzz

Gothic Versals

Shown here are the large capitals that were used during the Carolingian period as starting points on a manuscript page. They seemed to say, "Start to read here." They were sometimes heavily ornamented with part of the letter extending into the border and becoming part of the illumination. Uncial, Lombardic initials, and Roman capitals were also used in this manner.

Double-stroked letters are shown here.

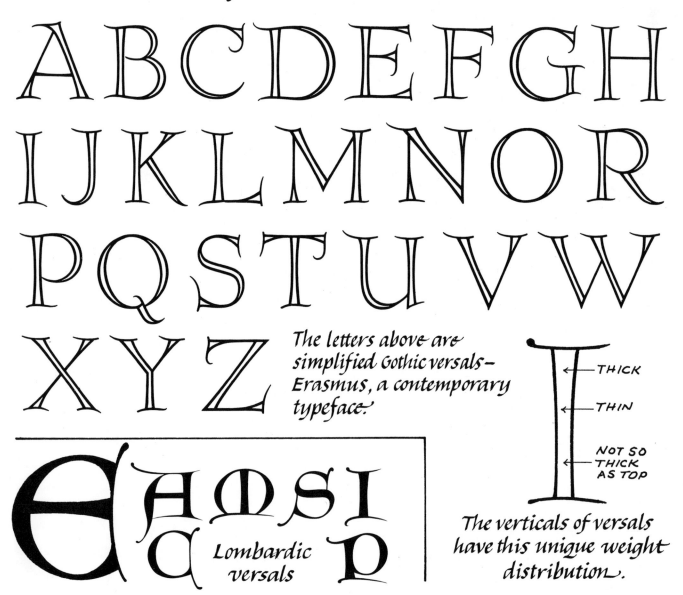

ABCDEFGH
IJKLMNOR
PQSTUVW
XYZ

The letters above are simplified Gothic versals— Erasmus, a contemporary typeface.

THICK
THIN
NOT SO THICK AS TOP

Lombardic versals

The verticals of versals have this unique weight distribution.

Humanistic Bookhand

In the 15th century southern Europeans developed the pointed black letter into a rounded style of Gothic called rotunda. The humanists of that period also revived Carolingian minuscule and developed a rounded Roman style known as Humanistic bookhand. Capitals, strongly influenced by classic Roman capitals, were also devised, thus creating a Roman capital (majuscule) and small letter (minuscule). One of the most significant developments was the design of a small Roman letter alphabet with ascenders and descenders.

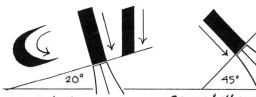

Most letters are drawn with a 20°-25° pen angle

Some letters (A, K, N, R, V, W, X, Y, Z) or parts are drawn with a 45° p.a.

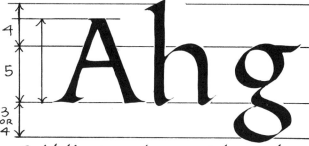

Guidelines are drawn as shown above. One unit is the thickness of the pen nib.

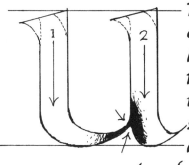

The vertical 2nd stroke of the letter u to the left does not turn to the right at the foot until it meets the 1st stroke (shown with arrows). This is also true for lowercase a and d.

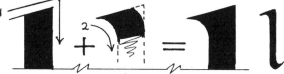

Triangular heads on lowercase letters are drawn as shown here. The steps can be reversed (1 is second to 2 above). Try drawing letters with a simple hook at the head as in the 1 shown above.

All round letters are based on the letter o and should have the same fullness of curves. The white spaces inside (voids) should be visually equal. The counters (white spaces between the vertical strokes) should be visually equal to the voids of the round letters. Note that the counters of the m are slightly smaller than the counter of n.

obcdepq hmnu

abcdef g

These small letters, and the capitals on the following page are
difficult letters to draw. Don't worry about the freely sketched forms;
this is not a mechanically drawn letter.
It will, however, always look good if drawn

hijklmno

like the letters drawn here. These letters were drawn with
a flat-edge sable brush. You should practice them with a brush as well as a flat pen

pqrs tuv

and a chisel-edge pencil. Draw circles on a separate piece.
Slip this piece under your tracing paper and practice drawing os. The edge of the pen
should always touch the circle's edge.

wxyz o o

ABCDEFG HIJKLMN OPQRSTU VWXYZ

These humanist capitals are drawn in the same way as the small letters. Twisting and turning the pen may be necessary when drawing the serifs. Draw them slowly and carefully. With practice they will constantly improve. Try different weight proportions as in the letters below. Try sketching the basic forms with the flat pen and sketch in the serifs later with a pointed pen, as in the letters at the bottom of this page. Remember to always to keep the set of the of the classic old-style Roman capitals in mind. Use pages 20 through 24 for reference. You should spend a lot of time with this style.

ABDABCD

Written Italic

All beautiful writing can be considered as calligraphy. Before the 16th century many beautiful calligraphic styles were written in Quadrata, Rustica, Uncial, Semiuncial, Carolingian minuscule, Gothic black letter, and Humanistic bookhand. In 1522 the Italian Ludovico Arrighi developed a beautiful slanted hand known as Chancery cursive. It is an outstanding example of slanted calligraphy, sometimes called italic, although italic is actually a typographic term. Shown here are the small letters and capitals.

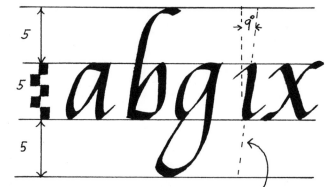

HEIGHT OF BODY (X-HEIGHT) OF LOWERCASE IS 5 PEN WIDTHS. ASCENDERS AND DESCENDERS ARE THE SAME.

ANGLE OF SLANT OF LETTERS IS 9° FROM THE VERTICAL.

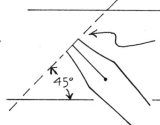

FLAT EDGE PEN IS HELD AT 45° ANGLE TO THE GUIDELINES

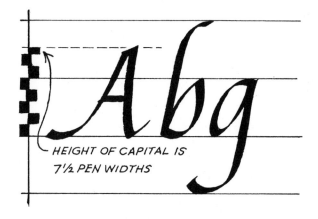

HEIGHT OF CAPITAL IS 7½ PEN WIDTHS

HEIGHT OF BODY

VARIATIONS FROM THICK TO THIN ARE CAUSED NATURALLY BY THE CHANGE IN DIRECTION OF THE LINE AND THE RETENTION OF THE 45° ANGLE, NEVER BECAUSE OF MANUAL PEN PRESSURE.

The pen is held lightly.

Beware of too much letterspace – pack the letters.

Use C-series Speedball pens and thin writing ink.

Do not retouch the letters with white paint.

ABOUT THE HOUSE

Do not use all caps in a word or phrase.

Join letters when convenient.

Practice these letters with other flat-edge tools — pencils, brushes, and scriber.

a b c d e e f g g g h i

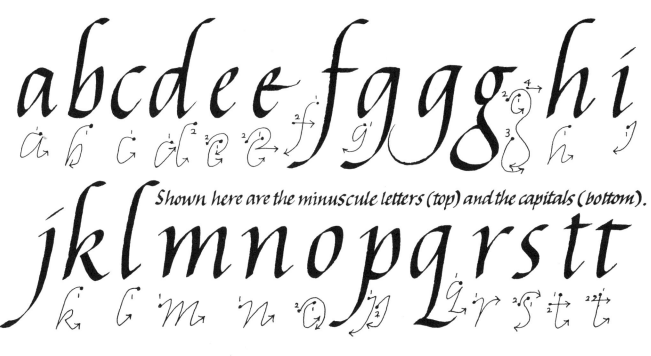

Shown here are the minuscule letters (top) and the capitals (bottom).

j k l m n o p q r s t t

u v v w x y y z

There are many variations of these letters.

A B C D E F G H I J K L
M N O P P Q Q R S T U
V W X Y Z & L B E O
W Th L G P

As in your own handwriting, in time, with much practice, you will develop a personal style.

Type

Johann Gutenberg printed his 42-line Bible around 1450 in Mainz, Germany. This significant event radically changed the direction of lettering styles. It was now possible to duplicate letterforms on the printing press. The letter style that Gutenberg used was a form of black letter called textura, and the text of his Bible was printed in changeable characters, or type. Printing spread rapidly to other countries, where the inevitable regional style changes took place. In Italy the printed condensed forms of Textura were soon changed to softer, round letters (Rotunda). Type designers soon turned to classic old-style Roman capitals and human-istic bookhand for inspiration — they were trying to duplicate the written forms. The specific requirements of printing demanded new letter variations, and the styles were changed to fit typographic needs. Thousands of type styles have since evolved — both for text (readability) and for display (flamboyant).

All type was at one time lettering: someone originally had to design it. Since this relationship has always existed, the lettering artist should conversely become familiar with the many type styles used today for inspiration. The significant styles of type developed from the incunabula period (1450-1500) to the present are shown below.

provides adorau gentes hoc uideli

Photostatic copies of Gutenberg's textura type (on the left) and Jenson's Venetian old style, Eusebius (1470). The type shown at the bottom is CLOISTER OLD STYLE, a modern adaption of Jenson's Eusebius. Even though it was designed hundreds of years later, it retains much of the character of the original Eusebius, as can be seen by comparing it with the Eusebius above.

abcdefghijklmnopqrstuvwxyz

ABCDEFGHIJKLMNOPQ

RSTUVWXYZ .,:;!?' 12345678

abcdefghijklmnopqrstuvwxyz

ABCDEFGHIJKLMNOPQ

RSTUVWXYZ 1234567890

GARAMOND old style was introduced in Paris in 1530 and quickly replaced the Gothic black letters. The letters had a greater contrast between thick and thin strokes, and the lowercase e had a horizontal cross bar for the first time.

abcdefghijklmnopqrstuvwxyz

ABCDEFGHIJKLMNOPQR

STUVWXYZ .,:;!? 1234567890

CASLON was introduced around 1726 in England. It is very legible when set in blocks. It has still greater contrast between thick and thin strokes.

abcdefghijklmnopqrstuvwxyz

ABCDEFGHIJKLMNOPQ

RSTUVWXYZ 1234567890

John BASKERVILLE introduced his transitional type in 1757 in England. His letters are relatively heavy; the hairlines are very thin; and the serifs have very small fillets. Note the lowercase g.

abcdefghijklmnopqrstuvwxyz
ABCDEFGHIJKLMNOPQR
STUVWXYZ

Giambatista BODONI introduced his modern Roman type in Italy in 1788. There is extreme contrast between thick and thin strokes; the letters are condensed (from previous types); and most of the serifs are hairlines with no fillets.

abcdefghijklmnopqrstuvwxyz
ABCDEFGHIJKLMNOPQRS
TUVWXY 1234567890

SQUARE-SERIF letters came on the scene around 1820 to answer a need for expressive display type for American advertising. Many ornate variations of square-serif type followed.

abcdefghijklmnopqrstuvwxyz
ABCDEFGHIJKLMNOPQRST
UVWXYZ 1234567890

The early Greeks inscribed letters with no serifs but SANS-SERIF letters did not appear again to a great degree until 1816 in England. Because the letters were strange they were called "grotesque." In 1898 Akzidenz Grotesk (Standard) type appeared but had little acceptance. In 1928 Paul Renner designed FUTURA at the Bauhaus in Germany, built on classic proportions. Since then Sans-serif letters have had wide acceptance.

Learning a New Type Style

When a new type style appears, learn it thoroughly. Obtain a large print of it. Draw guidelines on tracing paper to match the type and carefully draw the outline of the letters. Use pointed 2H or 4H pencils. Compose words and phrases as you go along and practice spacing. A softer pencil, HB or 2B, can be used to fill in the letters if you wish. For smaller sizes practice indicating the type with single strokes of a flat-edge or chisel-edge pencil.

Get on the mailing lists of type suppliers so that you get the latest styles as they appear. You may get a new idea for your own styling as you learn the one that you are tracing.

Enlarge the type sheet, left, to a convenient working size, below.

Drawing board

Lay tracing paper over the type and carefully sketch the letters.

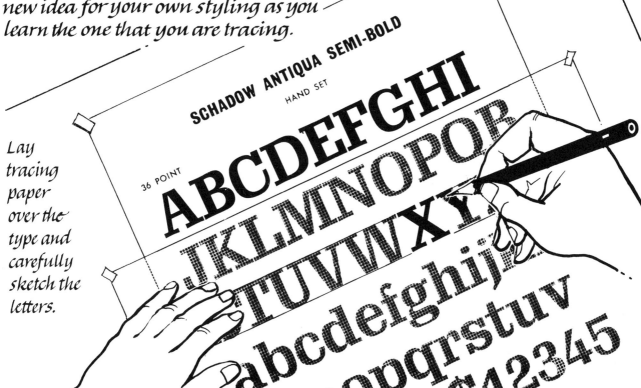

SCHADOW ANTIQUA SEMI-BOLD

HAND SET

36 POINT

ABCDEFGHI
JKLMNOPQR
STUVWXYZ
abcdefghijkl
mnopqrstuv
wxyz $12345

Geometric Old-style Roman Capitals

During the Renaissance many letter-ing designers used mechanical or geo-metric methods to design classic Roman capitals. Leonardo da Vinci designed an alphabet in this way. Some of his letters and those of other designers are shown here.

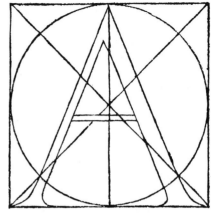

MOYLLUS 1529

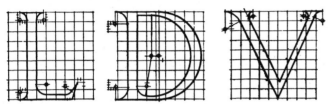

LETTERS ATTRIBUTED TO LEONARDO DA VINCI

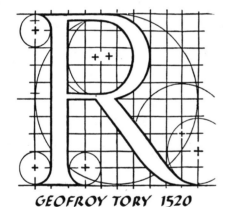

GEOFROY TORY 1520

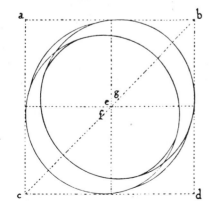

ALBRECHT DÜRER 1530

On the following pages is shown a method of drawing classic Roman capitals with mechanical instruments. You should never lose sight of the fact, however, that the best classic Roman capitals are drawn freely as shown earlier and completely finished free-hand without the aid of mechanical instruments.

These letters are semimechanically drawn. The heavy stroke (stem) is 1/11th of the height and the thin stroke (hair-line) is ½ of the stem. Make a small scale of these units as an aid. Crosses (+) denote the centers of circles for drawing arcs. Asterisks (*) show where the curves are hand-drawn. One unit is the thickness of the stem.

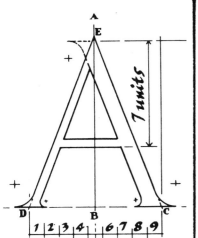

First construct line
AB and then △ EDC.
Note that point E
is above guideline.
Also note the
optional top of
A (dotted lines).

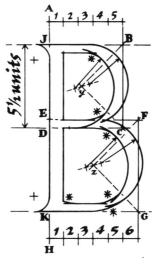

On line AH construct rectangles JBCD
and EFGK. From points B and C draw
45° lines to get "y". Through "y" draw
15° line. Find centers of circles ½ unit
on either side of "y". From F and G do
the same as above to find "z". Find cen-
ters for lower lobe of letter B.

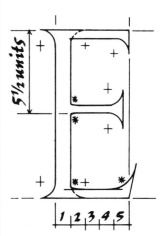

This construction
is for letters E, F,
and L. Note the
terminal endings
of the 3 horizon-
tal strokes.

For letters C and G

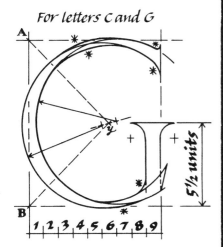

Through A and B
draw 45° lines to
get "y". Draw 15°
line through "y"
and find centers
of circles.

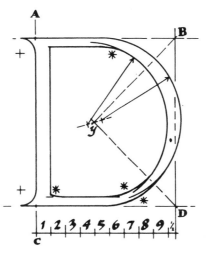

Draw 45° lines
through B and D
to get "y". Find
centers of circles
as before.

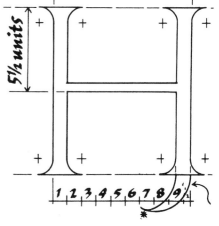

This construction is
for letters H, I, and J.
There are many var-
iations of the hook
at bottom of J.

47

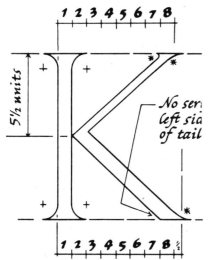

5½ units

1 2 3 4 5 6 7 8

1 2 3 4 5 6 7 8 ½

*No ser...
left sia...
of tail*

Note that the top of K
is smaller than bottom.
There is no serif on
the left side of the
tail. Two arms of K
form a 90° angle.

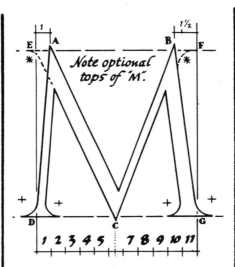

*Note optional
tops of "M".*

1 1½

E A B F

D C G

1 2 3 4 5 7 8 9 10 11

First draw rectangle EFGD.
Then find points A, B, and C,
which are above and below
guidelines. Note the option-
al tops of M (dotted lines).

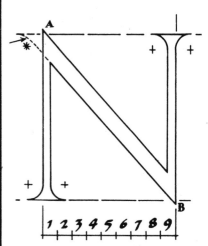

A

B

1 2 3 4 5 6 7 8 9

Note that the letter is
above and below guide-
lines at A and B.
Never draw a serif at
the bottom of N (B).

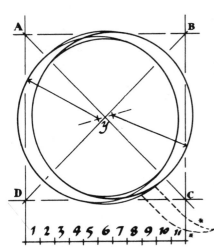

A B

y

D C

1 2 3 4 5 6 7 8 9 10 11

First draw square ABCD. Find
"y" by drawing lines AC and BD.
Draw 15° line through "y" and find
centers of circles, ½ unit from "y."
Where circles intersect, thickness
of letter should be ½ unit.

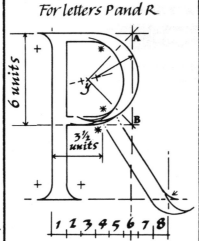

For letters P and R

6 units

A

y

B

**3½
units**

1 2 3 4 5 6 7 8

First draw 45° lines
from A and B to get
"y" and find centers
of circles. Note the end
of P's loop at center.
The tail of R has
optional ending.

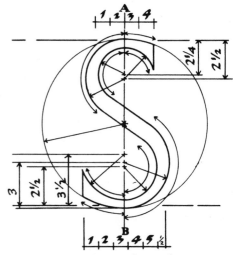

1 2 3 4

A

2¼ 2½

3 2½ 3½

B

1 2 3 4 5 ½

First draw line AB and
find center ⊛. Draw a circle
above and below guidelines.
Find centers of arcs on line
AB as shown. The two-pointed
arrows show length of arcs.

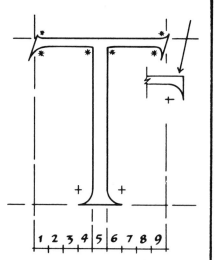

Note the optional
serif treatment
on the upper arm
(arrow).

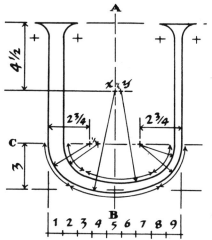

First draw lines AB and
CD. Find centers of all
arcs(+). Double-pointed
arrows show length of
arcs. Centers "x" and "y"
are ½ unit apart.

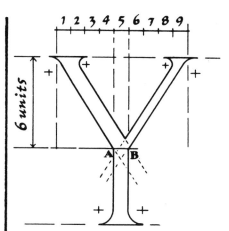

Find points A and B.
Note that these
points are directly
opposite each other.

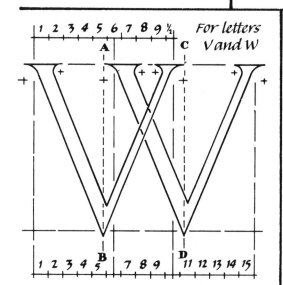

For letters
V and W

First draw lines AB and CD. Note
that the points of the letters at the
bottom are below the guideline.
This letter is the widest of all.

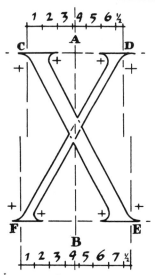

First draw line AB.
Then find points C,
D, E, and F. Top and
bottom are centered
on line AB

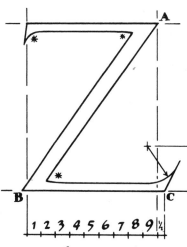

Top of Z is smaller
than bottom. Note
the serifs at the
terminals.
First find points
A, B, and C.

Roman Lowercase

In 1470 Nicolas Jenson, a French engraver working in Venice, Italy, designed the first significant old-style Roman lowercase letters for type. Minuscule small letters for type are called lowercase because they were kept in a drawer, or case, under the drawer that held the large capitals. Jenson's style was based on old-style classic Roman forms. Cloister, a typeface in use today, closely resembles Jenson's original style, Eusebius.

A method of constructing your own lowercase is to use the flat-edged pencil and single-stroke these forms, adding embellishments with a pointed pencil later.

bookhand of th

Written Renaissance bookhand had an influence on Jenson when he designed Eusebius.

oyſes naſcitur)ſed n eſtatur. Credidit eni

Photostatic copy of Jenson's type, Eusebius, 1470.

abcdefghijklm
nopqrstuvwxyz

Cloister— a 20th century typeface— a modification of Jenson's type.

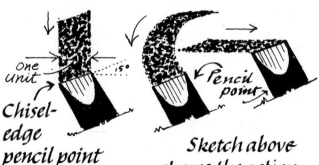

One unit · 15° · Pencil point

Chisel-edge pencil point

Sketch above shows the action of the flat edge in forming the strokes for lowercase letters. An angle of 15° to 20° of the pencil edge to the guidelines must be maintained with little twisting.

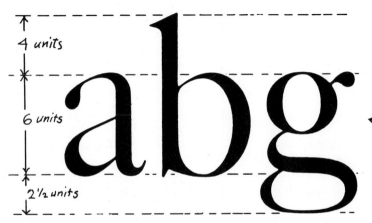

4 units

6 units

2½ units

The diagram at left shows how to establish guidelines for the letters on the facing page.

abcdefghijk
lmnopqrstu
vwxyz

The letters shown above are the type-face Caslon 540. Lay a piece of tracing paper over them and draw them with your chisel edged pencil held at a consistent angle (15° to 20°).

4
6
2½

abcdefghijk
lmnopqrstu
vwxyz

Also practice drawing these forms with a flat edge pen, brush, and two pencils as in the uncial lettering exercise.

Roman Italic

Italic is the slanted version of upright, vertical Roman lettering. The first lowercase italic typefaces were designed in 1500 by Francesco da Balogna (Griffi) for Aldus Manutius, a printer in Venice. The term "italic" presumably derives from the word "Italy"."

The design of italic lowercase was greatly influenced by Humanistic slanted calligraphy, an earlier written form. Aldus used upright Roman capitals with lowercase italic. Italic capitals were developed about 50 years later by the French. Decorative swash capitals were a still later addition to the italic family.

If the Renaissance type designers were strongly influenced by calligraphy, it is reasonable to refer to calligraphy again to understand and design roman

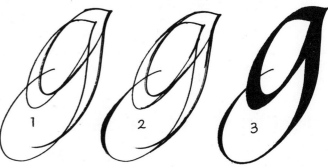

Hic elegos? impune diem consumpt
Telephus? aut summi plena iam n
Scriptus, et in tergo nec dum finiti
Nota magis nulli domus est sua, q
Martis, et æoliis uicinum rupibu
Vulcani · Quid agant uenti, qua

This is a photostatic enlargement of Aldine Italic, Venice, 1501.

italic. The g above shows the steps — (1) sketched out with the scriber, then refined (2), and finally finished (3).

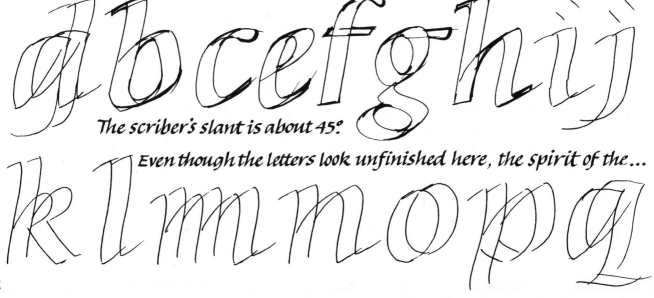

The scriber's slant is about 45°.

Even though the letters look unfinished here, the spirit of the...

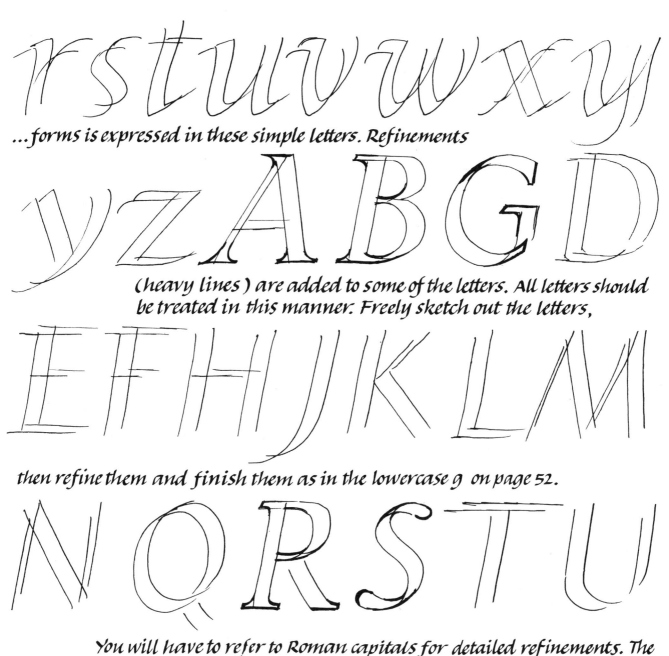

r s t u v w x y

...forms is expressed in these simple letters. Refinements

y z A B G D

(heavy lines) are added to some of the letters. All letters should
be treated in this manner. Freely sketch out the letters,

E F H J K L M

then refine them and finish them as in the lowercase g on page 52.

N Q R S T U

You will have to refer to Roman capitals for detailed refinements. The
guidelines are 4 for
ascenders, 5 for bodies,
and 3 for descenders.
Change them when
creating your letters.

W X Y Z

Calligraphic Type Styles

The designers of the first type styles were inspired by written calligraphic forms. The letterer of today can borrow ideas from many of the type styles that have been designed since then. Shown here are styles with an obvious calligraphic influence, and it is excellent practice to write them with a flat-edge tool. Modify them as you wish. Do not trace them — — write freely. Exact duplication is not necessary, unless you are indicating that particular type style in a layout.

Lydian

abcdefghijklmnopqrstuvwxyz

ABCDEFGHIJKLMNOPQRST

UVWXYZ 1234567890 .,:;!?""-

Lydian Italic

abcdefghijklmnopqrstuvwxyz

ABCDEFGHIJKLMNOPQRST

UVWXYZ 1234567890 .,:;!?'

Libra – has a strong uncial influence

abcddeffghijklmnopqrstuvwxyz

1234567890 .,:;!?'""- $¢

Cloister Black

abcdefghijklmnopqrstuvwxyz

ABCDEFGHIJKLMNOPQRSTUVWXYZ

Excelsior Script semi Bold. Try writing it with a pointed pen.

abcdefghijklmnopqrstuvwxyz A B C D E F G

H I J K L M N O P Q R S T U V W

Legend

A B C D E F G H I J K L M N O P Q R S T U V W X Y Z

abcdefghhijklmnyopqrstuvwxyz

Studio

abcdefghijklmnopqrstuvwxyz

ABCDEFGHIJKLMNOPQRSTUVWXYZ

Brush

abcdefghijklmnopqrstuvwxyz ABCDEF

GHIJKLMNOP2RSTUVWXYZ

Balmoral

A beautiful contemporary style, reminiscent of early Quadrata capitals.

ABCDEFGHIJKLMNOPQRSTUVWXYZ

Formal Script

Mercantile, social, and court writing developed alongside manuscript writing. It was not formal and ordered — at a glance it looked like chicken scratchings compared to the beautiful scripts that exist today. The Industrial Revolution in England (around 1700) in combination with copperplate engraving resulted in the development of a letter style known as formal script. Letter designers changed cursive calligraphic writing (done with a flat pen) into a running, joining, and very slanted style (done with a flexible pointed pen). Master engravers and calligraphers produced copy sheets and copybooks to be used as models. Engraving tools and the pointed pen contributed to the character of the letters more than anything else. This style had a great influence on the Bodoni typeface, a modern Roman style designed around 1789 by Giambattista Bodoni.

Small-letter cursive writing —
Rome, 3rd century.

Sample of Roman writing of the
7th century.

Formal italic writing at the time
of the Renaissance, 1500-1550.

18th century pointed pen writing

Speak sweetly — you may
have to eat your words

Computer-assisted photocomposition
of the 20th century.

facile a jmiter pour les femmes.

Lettering by Lucas Materot (Avignon, 1608).

Formal Penmanship

The unretouched writing above was done directly with a pointed spring pen. This is the only letter style so far that uses pen pressure for styling the letters. Extra pressure is applied to the pen in writing the heavy strokes. You should practice writing formal script in this way.

Formal Penmanship much twisting and turning

The writing above was done with a flat edge C-4 Speedball pen, twisting and turning it to get the form, with no extra pressure on the pen nib needed, as in the top example. One point of the flat edge is used for the hairlines. This method should also be practiced.

The style is sometimes called English roundhand or copperplate. Pratt Spencer, an American writing master, produced copybooks of the style around 1825, and many lettering artists today refer to this script as Spencerian. It resembles elegant handwriting. It has a severe slant (about 55°). The downstrokes (↙) are heavy, and the upstrokes (↗) are thin. Overly flourished capitals are often used.

A B C D E F G
abcdefghijklmnopqrstu

Excelsior script (above), Commercial script (below), and Bank script (bottom) are three of many handsome typefaces that can give inspiration to the lettering designer.

A B C D E F G H I J K L
abcdefghijklmnopqrstuvw

A B C D E F G H I J K L M
N O P Q R S T U V W X Y Z &
abcdefghijklmnopqrstuvwxyz 1234.,!?

Elements of capital
construction are
shown here:

Letters slant
at 54°

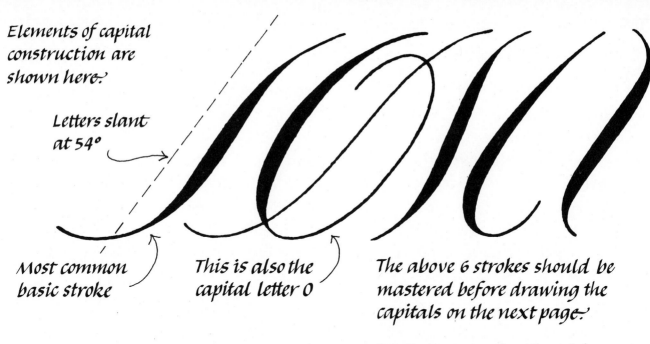

Most common
basic stroke

This is also the
capital letter O

The above 6 strokes should be
mastered before drawing the
capitals on the next page.

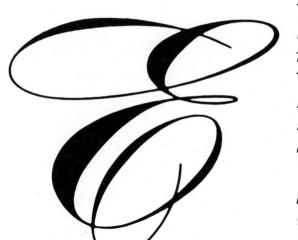

The curved hairlines in the flourishes may
have a slight accent but are never heavier
than the main reading parts of the letters.
The heaviest strokes of the capitals should
be slightly heavier than the weighted
strokes of the small letters. Hairlines are
all the same.

As you develop your lettering, turn the
paper at different angles to correct the
graceful curves.

The beautiful letters below are part of
an alphabet designed by M.M.Davison
for Photolettering, Inc.

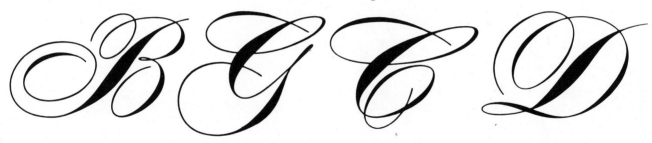

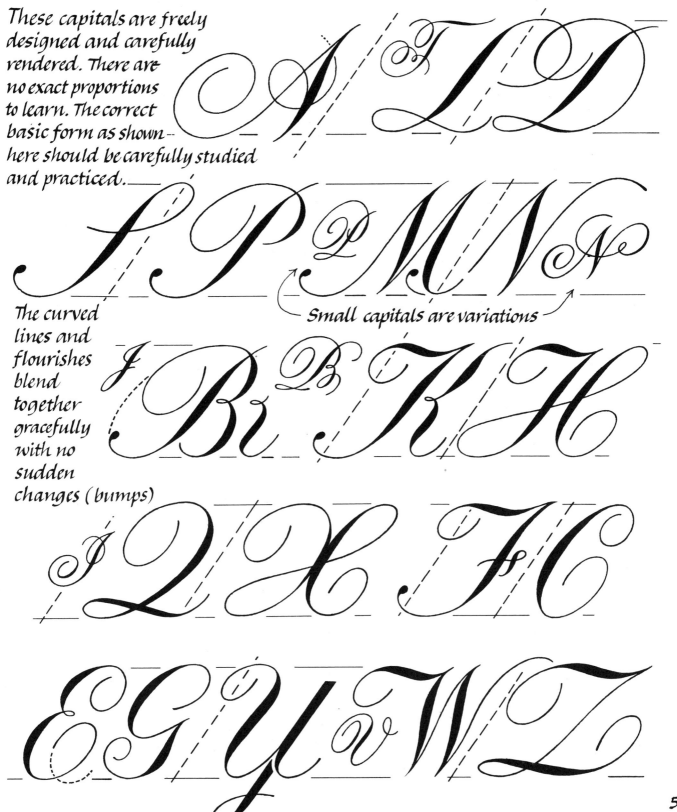

These capitals are freely designed and carefully rendered. There are no exact proportions to learn. The correct basic form as shown here should be carefully studied and practiced.

The curved lines and flourishes blend together gracefully with no sudden changes (bumps)

Small capitals are variations

Elements of lowercase construction are shown here.

Angle of slant of formal script. This angle can change to create a different style but must always be consistent.

Shown above are 6 basic strokes for forming most of the lowercase script letters. The angle of slant is appoximately 54° and can be determined by the diagram to the right. You can cut a small cardboard triangle and use it against a T-square when designing your script. The diagram to the left shows the correct turning of the forms from the accented heavy down stroke to the hairline. The arrows show where the circlelike inside character changes weight.

3
4

Dot over i should be an oval, not a circle.

Common Errors

Badly designed (see above)

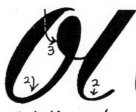

e in oil

The loop is too low.

Too gradual a change from heavy to thin.

Hairline joiners should be tight (dotted line) not loose, as shown with double arrows.

Hairlines should be the same weight (2). Ball joining element (3) is too large.

Oval part should slant less than 54°.

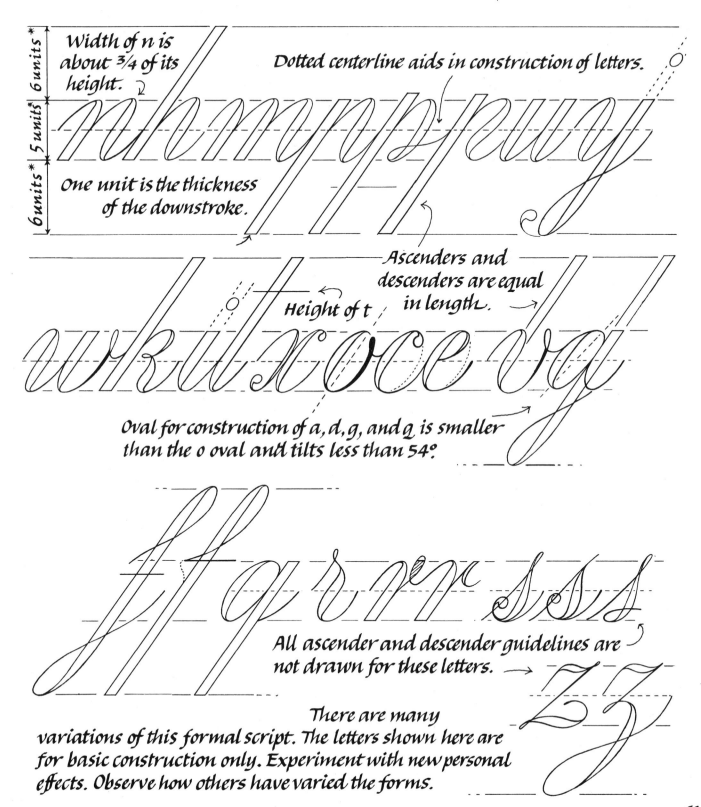

Width of n is about 3/4 of its height.

6 units *
5 units *
6 units *

Dotted centerline aids in construction of letters.

One unit is the thickness of the downstroke.

Ascenders and descenders are equal in length.

Height of t

Oval for construction of a, d, g, and q is smaller than the o oval and tilts less than 54°.

All ascender and descender guidelines are not drawn for these letters.

There are many variations of this formal script. The letters shown here are for basic construction only. Experiment with new personal effects. Observe how others have varied the forms.

Informal Script

There are very few rigid rules for drawing or writing free or informal script. One rule is that it must always be readable (legible). It should be done with a free movement of the arm and hand — swing it. It will probably express your own handwriting, which may lead you to develop a very personal style.

Practice the forms shown here if your handwriting is unsatisfactory. Your assignment can be written over and over again — cut apart and save the best parts. Combine them into one piece as shown below. Spray with workable fixative and retouch with opaque white paint for your final piece. If you photostat it the cut marks will not show, and you can enlarge or reduce as desired.

Any tool can be used. If you write with a flat edge, always hold it at the same angle. Use thin ink (black writing ink) that flows freely.

Build up a reference file of informal script samples from greeting cards or general advertising.

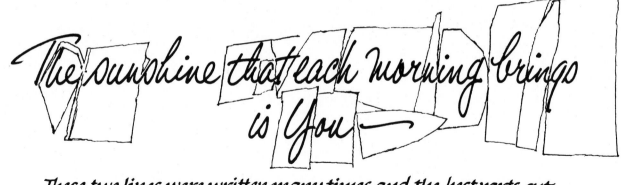

These two lines were written many times and the best parts cut apart and assembled as shown. The lettering was then photostated.

The sunshine that each morning brings is You —

If necessary, the cut marks are retouched. The above two lines show what the lettering finally looks like. It is now ready to paste down on the mechanical.

a b b b c d e e e f
g h j k l m n o
p q r r r s s s
u v t v w x y
z z z

This alphabet is one of many that
can be used for practicing free script.
The strokes start at the stars and
continue in an unbroken flowing line.
Use smooth surfaced paper. All letters of a
word do not necessarily join.

A Valentine for Son and his Wife

Informal script can bounce — it does not have to be perfectly aligned to a guideline.

It is an excellent exercise to freely sketch ovals of different shapes and sizes as a warmup to writing informal script.

Nolans

First write the letters freely with a pen, and then ...

Nolans

... make the reading parts of the letters heavy and retouch with white.

Friends
Peace
Love

This lettering was written with an old ruling pen with a nib that was ground down on a sharpening stone.

Endless as time...
deep as the sea...
my love for you.
Happy Valentine's Day

Informal script is used in the greeting-card field. Perhaps you can freelance -- send samples.

But if we did, you better believe
You'd have been picked anyway!!

The slanted informal script above was written with a B-3 Speedball pen.

Especially a handsome dog like you!!

This vertical script was also done with a B-3 pen and retouched.

How does this one grab you?

Written with a B-2 Speedball pen and the free ends squared off by retouching.

A Mother's Love

This script was written with a D-2 (oval nib) Speedball pen and retouched.

The thoughts are sentimental
The feelings, warm and true
The memories, sweet and loving
Because they're all of you.

The script to the left was written many times with the side of a pointed brush, cut apart, repositioned, and retouched. It has been greatly reduced from the original size.

Pencil Informal Script

If you have your own photostat machine or if a service is available, a good method of developing informal script is shown below. Sketch out your own script in pencil on tracing paper. Redo it as often as you like until you get just what you want. Back up your final tracing with a white opaque card and enlarge it in the machine to any convenient working size.

When you shoot the print, force the contrast by allowing less time than for normal setting. When the ink is dry, ink it in, retouch, cut apart, and respace or realign if necessary. Shoot another stat — this time do not force the contrast — and reduce it to the desired size. When dry, the print can be retouched. The final print becomes the final art for reproduction.

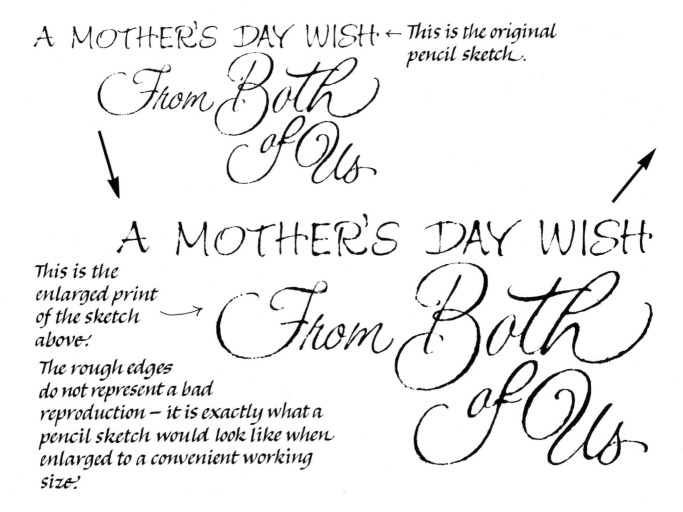

A MOTHER'S DAY WISH ← This is the original pencil sketch.

From Both of Us

This is the enlarged print of the sketch above.

The rough edges do not represent a bad reproduction — it is exactly what a pencil sketch would look like when enlarged to a convenient working size.

A MOTHER'S DAY WISH

From Both of Us

A MOTHER'S DAY WISH
From Both of Us

This is what the print on the opposite page looks like after it has been inked in and retouched by a lettering artist.

↓

A MOTHER'S DAY WISH
From Both of Us

This is the final print—reduced to the required size for the mechanical paste-up before reproduction.

Speedball Informal Script

Pen nibs with a variety of tip shapes can be used to create many free-script effects. The B series Speedball pen (round tip) will maintain the same weight throughout. The free endings of the letters can be retouched to give a flat-edge rather than a rounded look. The D and C series Speedball pens (oval and flat-edge) will give a different look (thick and thin) to the appearance of the line if the pen is held at the same angle throughout. The procedure outlined previously can be used—write many lines, selecting the best parts of each, paste them together, and correct the spacing. Shown here are examples of informal script written with these pens. Other pen manufacturers make similar nibs that are equally good. Fountain pens with interchangeable nibs are also available at the art-supply store.

First draw a pencil line ...

Love to Both of You

...and then freely write your script across the line. This will help you align freely drawn script. The pencil line is erased later and the lettering is retouched.

But if they boast of things like that

Written with a B-3 pen and the terminals retouched with white opaque tempera.

Practice drawing free ovals with the pen you are about to use. The ovals should be different sizes, in all directions, and written quickly.

Calligraphic style

The above is an unretouched example of how freely drawn calligraphic script looks – drawn with a C-4 pen nib held at one angle throughout.

● ╱ ● ■
B **C** **D** **A**

The above diagram shows the ends of the Speedball pens as they are designated by letters.

Roses are red — Violets blue

The above is a free calligraphic style written with a C-4 Speedball pen. It is not retouched. Slants and weights can change to make variations. The pen angle does not change.

It shouldn't happen to a dog!

This was written carefully with a B-2 nib, retouched, and reduced. If one or more letters are not quite what you want, letter extras and paste them in. This is particularly true with capitals.

Sugar is sweet and good in Coffee

This freely written script was done with a C-5 pen and reduced. It is unretouched.

Good Bye and Good Luck

The above was written with a D-3 pen nib and is unretouched. It would normally be retouched, for the letters have ragged edges in some parts. The capital L would be redone and replaced. It doesn't look good here.

Diamonds big as rocks

This is unretouched handwriting. If your handwriting is not so good, perhaps you have a friend who has neat, readable script writing and you can use it!?! This was done with a B-5 nib.

Decorative Letters

Decorative letters (mostly capitals) have been used throughout the history of lettering. In early manuscripts a large letter was used on a page to show where the reading text started. These letters were often ornamented. Elaborate border decorations often extended from some part of the large letter. In the last half of the 1800s overly ornament styles were in fashion, and many experts consider this period a low point in the history of letter design.

Any letterform can be made into a decorative letter with one or more of the following effects: adding decorative material around or through the letter, outlining it or shading it or both, decorating the face of the letter, distorting the form, or using a color that contrasts with the text. You should generally avoid using decorative letters for an entire word.

Some letters are inherently decorative, such as Gothic black-letter capitals and flourished formal-script capitals.

This ornate letter was first designed as a simple letter B, and features were later added and changed until a satisfactory result (above) was achieved. No matter how decorative the letters may be – they must always "read" as recognizable letters.

These two letters are from alphabets designed to be used as starting initials to a paragraph or page heading.

OUTLINE

OUTLINE AND SHADED

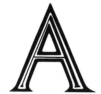

INLINE AND OUTLINE

DECORATION AROUND LETTER

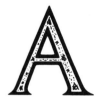

DECORATION WITHIN LETTER

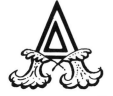

DECORATION ON ½ THE LETTER

DISTORTION OF THE FORM

FORM LETTER WITH ILLUSTRATION

PICTORIAL MATTER

COMBINATIONS

Shown above are the decorative effects you can use to design a decorative— letter. Shown below are a few examples employing one or more of these effects.

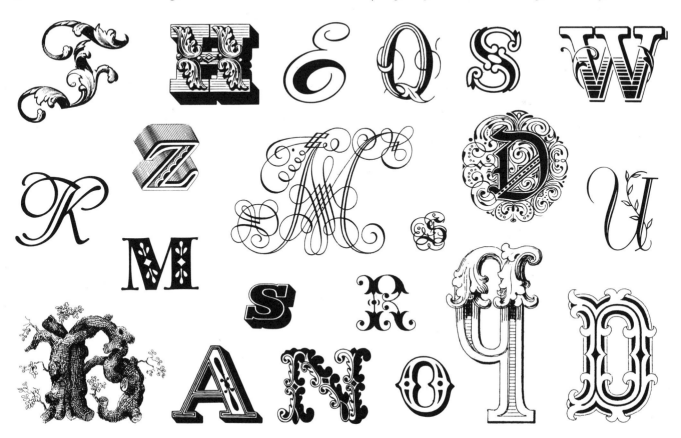

Square Serif

Around 1820 the needs of American advertising resulted in the development of unique and expressive type styles for display purposes (headlines, posters, and the like). The use of varied distortions, weights, shadings, and outlines led to a dearth of unusual styles. One significant style, a heavy, dark letter with squarish serifs, emerged at the same time as the diggings along the Nile in Egypt yielded fantastic discoveries. The letters were reminiscent of ancient hieroglyphics, so the style became known as Egyptian.

These letters are basically Roman or sans serif in style with heavy, square serifs as in the Stymie type shown here. Some common type names are Memphis, Karnak, Cairo — all Egyptian.

ABCDEFGHIJKLM
NOPQRSTUVWX
YZabcdefghijklmno
pqrstuvwxyz.,!?234

AIJKLM aijklm
Karnak type

AND THE MOST DUR
and the most durable
Memphis type

A modification of square serif is a letter with thick and thin strokes and slablike filleted serifs called Clarendon.

AG

Demonstrated here is an exaggerated square-serif modification of a Barnumlike letter called Hidalgo. It is of interest to note that the typewriter was invented around this time and that the letter style used for it was a square or slab serif.

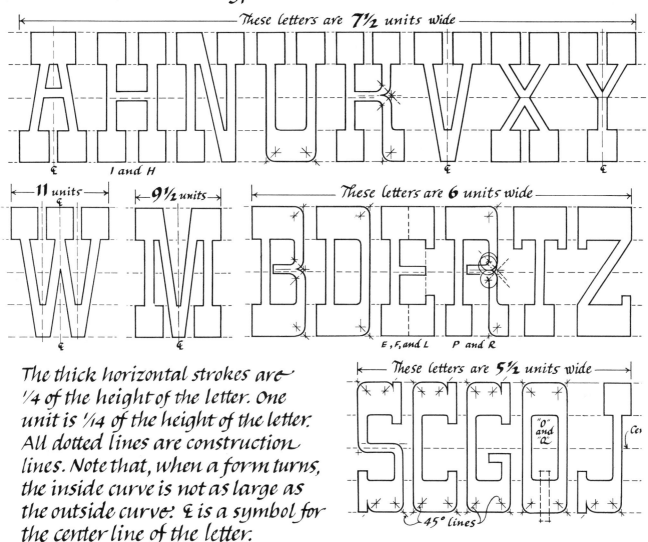

These letters are 7½ units wide

₵
I and H
₵
₵

11 units
₵

9½ units
₵

These letters are 6 units wide

E, F, and L P and R

The thick horizontal strokes are ¼ of the height of the letter. One unit is ¼ of the height of the letter. All dotted lines are construction lines. Note that, when a form turns, the inside curve is not as large as the outside curve. ₵ is a symbol for the center line of the letter.

These letters are 5½ units wide

"O" and "Q"

₵

45° lines

ABCDEFGHIJKLMNOPQRSTUVWX
YZabcdefghijklmnopqrstuvwxyz12

American Typewriter typeface with rounded slab serifs.

Sans Serif

Early Greek lettering had no serifs. The Romans added them, and not until the 1800s did sans (without)-serif letters appear again. Because these letters were strange, they were called Grotesk in Europe. In America they were miscalled Gothic, probably because they were heavy and black on the page. The true Gothic is the black letter discussed earlier.

Late in the 1800s a typeface was designed by the Berthold typefoundry in Europe called Akzidenz Grotesk. Around 1925 Paul Renner designed Futura, a semigeometric type with classic proportions. It is still widely used today. Optima, a type designed by Hermann Zapf in 1955, also has classic proportions but with slightly splayed strokes. A very popular sans-serif type much in use today is Helvetica, which was designed in Switzerland. Its proportions are not classic but rather modern in that the letters look as if they were all the same width.

ΛΝΕΚΤΣΓΡ

Greek letters from a B.C. vase

ABCDEFGHIJKLM
ABCDEFGHIJKLMNOP

The above two lines are old-style Roman capitals. Note the set of the letters.

ABCDEFGHIJKLMNOPQ

FUTURA DEMIBOLD ↗ ↖ OPTIMA

ABCDEFGHIJKLMNOPQR

These two lines of sans-serif letters have sets similar to the old-style letters above.

ABCDEFGHIJKLMNOP

STANDARD ↗ ↖ HELVETICA

ABCDEFGHIJKLMNOP

The set of these two sans-serif lines has changed considerably from the old-style. The letters seem to be all the same width.

The diagrams to the left show how the flat-edge tool (chisel-point pencil in this example) changes its position to form an o. In the first example the left and right curves are drawn as the pencil changes position. In the second example the top and bottom are drawn in overlapping strokes. You should practice sans-serif with other flat-edge tools. This is commonly called chisel-point lettering.

The alphabets shown below are—
major styles of sans-serif type. They
should be compared and studied by
the letterer to get ideas for drawing
new sans-serif styles. Type has always
been a source of inspiration for the—
handletter. At one time the reverse
was true.

STANDARD (Akzidenz Grotesk)

abcdefghijklmnopqrstuvwxyz

ABCDEFGHIJKLMNOPQRSTUVWXYZ

UNIVERSE 55

abcdefghijklmnopqrstuvwxyz

ABCDEFGHIJKLMNOPQRSTUVWXYZ

HELVETICA

abcdefghijklmnopqrstuvwxyz

ABCDEFGHIJKLMNOPQRSTUVWXYZ

OPTIMA

abcdefghijklmnopqrstuvwxyz

ABCDEFGHIJKLMNOPQRSTUVWXYZ

FUTURA MEDIUM

abcdefghijklmnopqrstuvwxyz

ABCDEFGHIJKLMNOPQRSTUVWXYZ

On the following pages the specific characteristics of FUTURA DEMIBOLD are shown.

When Futura was originally designed in the 1920's, Paul Renner, the designer, tried to reflect the spirit of the times with this alphabet. Main characteristics of the sans-serif lowercase are shown below.

Guidelines are established as shown here. One unit is the the thickness of a vertical stroke (A).

When a curved circular part joins a vertical, the part is thinner at the point of joining (B).

Curved terminals can have vertical endings as shown in the shaded area above. These parts are handdrawn.

On the alphabet on the next page, curves are handdrawn at the asterisks (*).

Widths of all letters are shown with a black bar above or below the letter. This bar represents the height of the body of the lowercase letters, and the widths are more or less the same dimension.

This schematic drawing demonstrates the tapering of some strokes (diagonals meeting verticals), which is necessary in some letters. The tapering is very slight—not as extreme as the example here, which is exaggerated.

The shaded part is the tapered stroke.

Centers for arcs are found by drawing 45° angles from corners (C). Where arcs are drawn from almost the same center, the distance from the centers is ¼ unit.

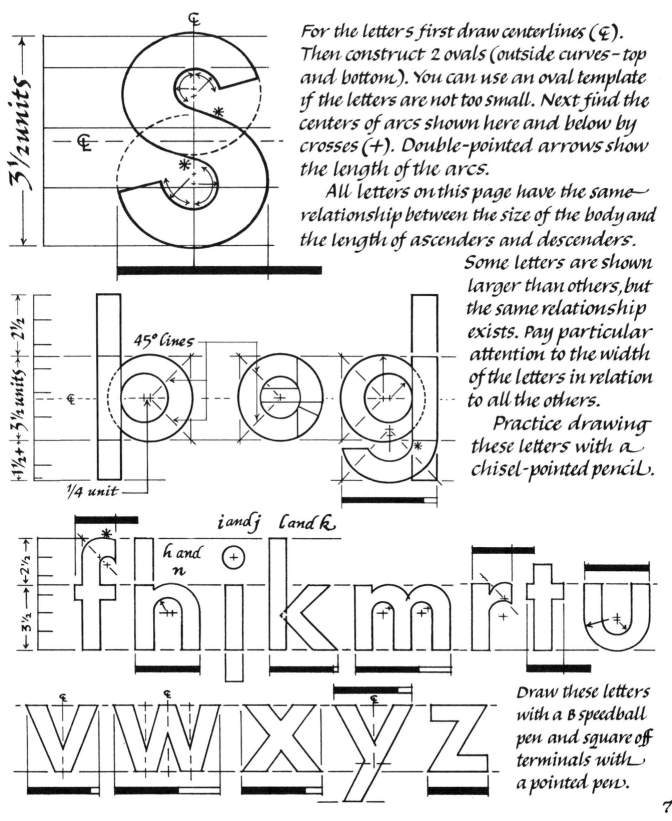

For the letter s first draw centerlines (℄). Then construct 2 ovals (outside curves – top and bottom). You can use an oval template if the letters are not too small. Next find the centers of arcs shown here and below by crosses (+). Double-pointed arrows show the length of the arcs.

All letters on this page have the same relationship between the size of the body and the length of ascenders and descenders.

Some letters are shown larger than others, but the same relationship exists. Pay particular attention to the width of the letters in relation to all the others.

Practice drawing these letters with a chisel-pointed pencil.

Draw these letters with a B speedball pen and square off terminals with a pointed pen.

Much of the information given for the construction of lowercase sans-serif letters also applies to the capitals. The capitals here are drawn almost completely by mechanical means with the use of drafting tools. However, the letters should be practiced freely with a flat-edge tool after the construction details are understood.

All horizontal strokes are slightly thinner than verticals.

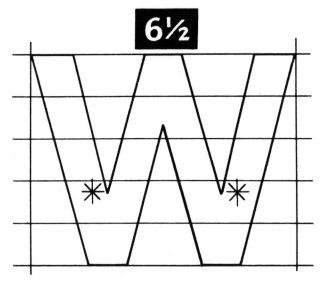

This shows how the letter W is formed. The letters are 5 units high, one unit being the thickness of a vertical stroke. The black numbers at the top of the letters show how many units wide the letters are, and letters are grouped according to width. Asterisks (*) show where the strokes taper to allow more white space. Centers for drawing arcs are shown with small crosses (+).

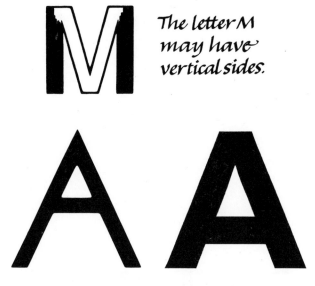

The letter M may have vertical sides.

In light sans-serif letters the A, M, N, W, and V have pointed tops or bottoms. In bolder versions these points become flat at the guidelines as shown to the right in the above diagram.

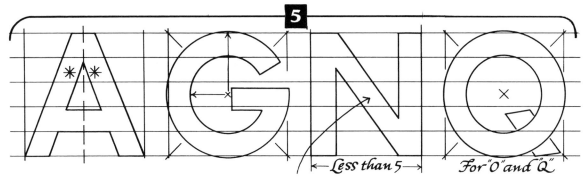

5

Less than 5 → | For "O" and "Q"

Thinner than one unit.

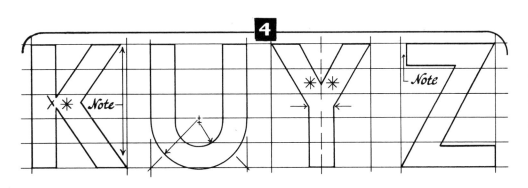

5 Note

4

Less than 4 | More than 4 | For "H," "I" and "J"

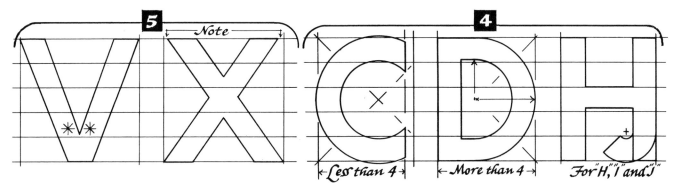

4 Note | Note

Corners of all squared-off strokes can be "pulled" out with a pointed pen. Careful!! Not too much.

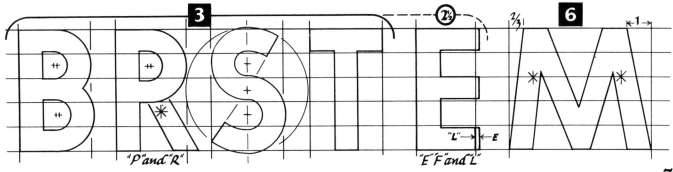

3 **2½** **⅔** **6** ← 1 →

"P" and "R" | "L" → E | "E" "F" and "L"

Sans-serif Italic

Roman is a letter style we have investigated at length in previous pages. The term "roman" also means upright or vertical when referring to the position of a letter. Italic is the slanted or tilted form of any style – as opposed to roman (vertical).

Italic has been used most often for emphasis in a mass of vertical letters. It is different – it stands out from the other roman letters. It has also been used as a subhead to support the main caption in a layout that is roman.

The italics are usually included in a complete typeface showing. Some newspapers and magazines use italic sans-serif captions throughout the publication. This is a current fashion and will be replaced by some other idea in the future.

The italic of any style keeps all of characteristics of the style but is slanted.

On the facing page are some outstanding examples of italic sans-serif typefaces shown for comparison.

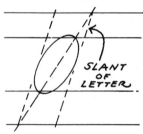

When ovals meet straight lines to form letters, the oval tilts so that its major axis is drawn as shown to the left.

76ers going to Boston with two players hurt

Caption in the Philadelphia Bulletin

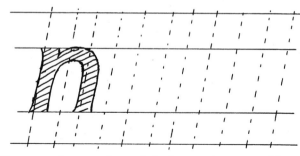

Draw slanted guidelines in pencil before designing your italics. Slant should be about 10° from vertical.

Come' con la esperientia della penna potrete' vedere', seguendo il modo mio sopradetto

The first italics were the calligraphic humanistic writings of the Renaissance. Typefaces were designed later using these writings for inspiration. Refer to calligraphy when designing your sans-serif italics. Much is to be learned from it.

ABCDEFGHIJKLM
ABCDEFGHIJKLM

Italic looks condensed but actually takes up almost the same space that roman does.

abcdefghijklmnopqrstuvwxyz

ABCDEGHKLMNOPRSTUVW

Lydian Italic

abcdefghijklmnopqrstuvwxyz

ABCDEGHKMNOPRSTUWXYZ

Alternate Gothic #2 Italic

abcdefghijklmnopqrstuvwxyz

ABCDEGHKMNORSTUWXYZ

Helvetica Italic

abcdefghijklmnopqrstuvwxyz

ABCDEGHJKMNORSTUWXYZ

Futura Demibold Oblique

abcdefghijklmnopqrstuvwxyz

ABCDEGHKLMNORSTUWY

Optima Italic

Some capitals have been omitted to save space. They can be seen in other letters.

Speedball Sans Serif

The round-tipped Speedball-pen nib can be used to write the sans-serif letter. It is single-stroked and fast — good for signs and charts. The direction and sequence of all strokes is shown in the alphabets. The light-lined boxes around each capital shows the relationship of the letter width to its height. A variation of this style is to square off the ends of strokes with a pointed pen. Try other variations such as condensing and extending letters — in each case the sequence and direction of the strokes remain the same.

ABCDEFGHJK

Try drawing the letters with a D-nib (oval)...

ABCDEFGHIJK

...or a C-nib (flat edge).

The sequence and direction of the strokes are the same as for the B-nib shown on the facing page. Try nibs of different sizes.

The style is good for fast signs.

Parts of the letters can be squared-off (arrows), giving a different look.

CONDENSED
EXTENDED

Try condensing and extending the letters. The strokes are the same as for the B-nib.

The small letters are ⅔ the height of the capitals.

Jog

The ascenders and descenders are the same.

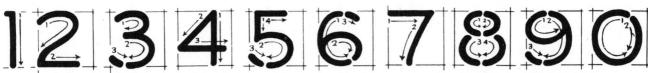

With the exception of one, all the numbers are about the same width.

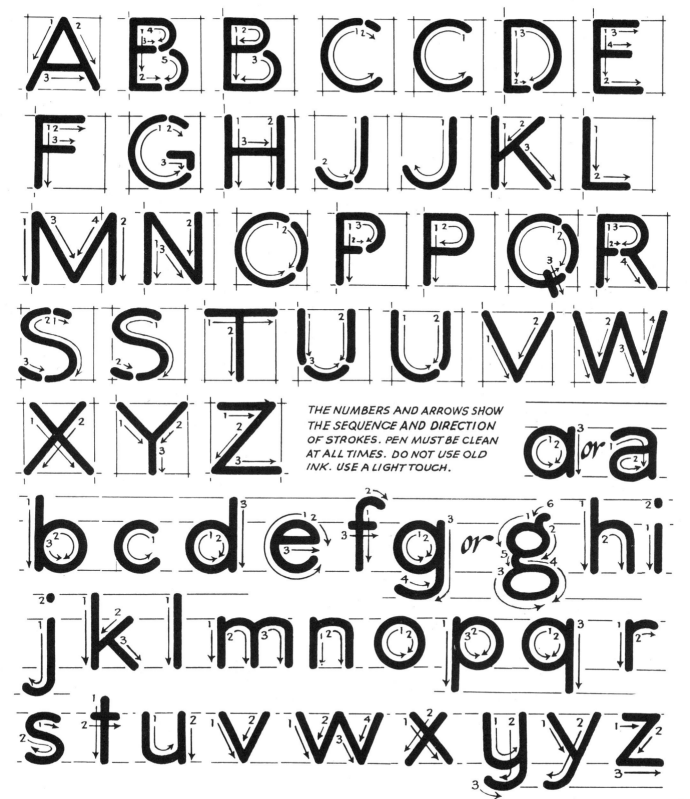

THE NUMBERS AND ARROWS SHOW
THE SEQUENCE AND DIRECTION
OF STROKES. PEN MUST BE CLEAN
AT ALL TIMES. DO NOT USE OLD
INK. USE A LIGHT TOUCH.

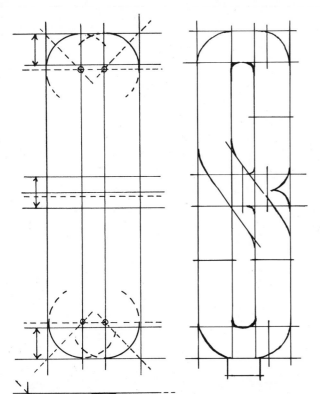

Flat-sided Sans Serif

The diagrams on this page show how flat-sided sans-serif capitals are formed. One unit is the thickness of a vertical stroke. Horizontal parts are slightly thinner, as shown with arrows on the first diagram to the left. This diagram shows the basic structure for most letters. The second unretouched diagram shows how these letters (BCDEFGHIJLOPQRSU) are formed on the first diagram. The letters at the bottom show the rest of the alphabet. In these diagonal strokes have parallel sides (except those in AVKYX), and the verticals get thinner on the inside parts as they converge with other strokes. Study the letters carefully. Dotted lines are not parts of letters. ₡ means center-line. The letter W is formed with 2 Vs. The letter A is upside down and is the same construction as V. The diagram to the left is an enlarged drawing showing how letters curve at the top. Note all spaces. The letters are about 9 units high.

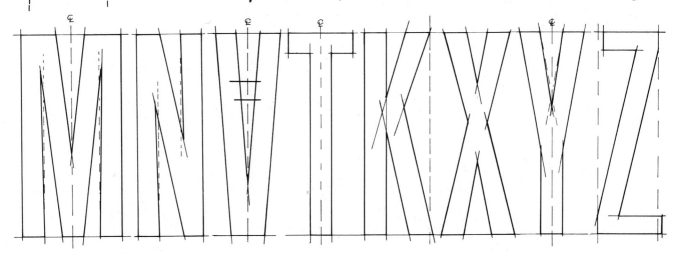

Capital height

abcd m

The flat-sided small letters are drawn in the same manner as the caps. When a curved part meets a straight part, as in the tops of the m to the left, the part gets much thinner, as you can see. An oval template might be used to draw the outside curves on some letters, but it is best to draw all curves without the use of mechanical aids. Where curves meet straight strokes, be careful not to get a "bump".

efghiklmnop

qrstuvwxyz

Brush Lettering

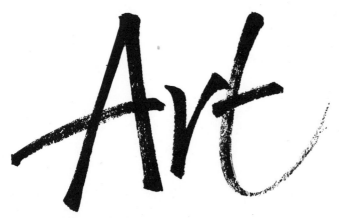

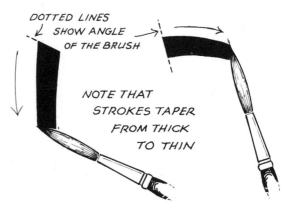

DOTTED LINES SHOW ANGLE OF THE BRUSH

NOTE THAT STROKES TAPER FROM THICK TO THIN

Practice these 2 strokes with a pointed watercolor brush.

Lettering written with a brush exhibits the characteristics of the brush, which are evident in the images produced (illustration). The forms shown here are models for the beginner to practice. After much practice the lettering will assume a personal style.

The pointed watercolor brush is held so that the side of the brush is used. The more pressure you apply, the wider the stroke. The flat-edge brush requires much turning and manipulation to form the letters and is more difficult to handle.

The alphabet below is a good model to use for practice. It is Typositor, F-29. Note that the heavy parts are double-stroked.

A flat-edge brush is used here. Practice turning it as you draw the letters.

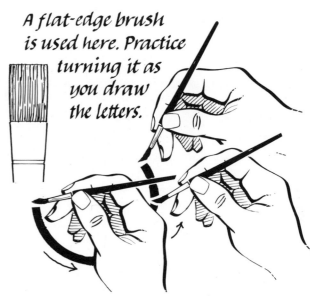

The hand turns as the brush is kept perpindicular to the line of direction (arrows) of the stroke.

abcdefghijklmnopqrstuvwxyz
ABCDEFGHIJKLMNOPQRSTU
VWXYZ!?1234567890

eb
aa
ar

Black poster paint can be thinned with water on a spread card with the brush before lettering. Newspapers can be turned on the side so that the column lines become guidelines for practicing brush lettering. The brush need not be kept at a rigid angle throughout — it can be changed at the convenience of the writer.

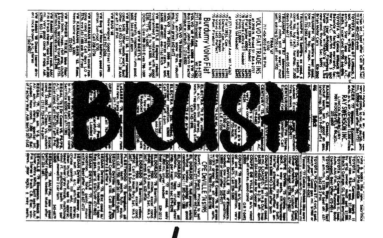

The flat-edge brush should be used for practicing any of the letters on the preceding pages for which a flat-edge tool is required. The brush is flexible, however, and requires much control.

It should be held in an upright, almost vertical position. It is controlled by the thumb, index, and middle fingers. Try loading your brush with paint for a different effect.

On the walls of Pompeii handsome inscriptions were painted with brush

— preserved by volcanic ash during the eruption of Vesuvius, 79 A.D. The brush was first used by the Romans for laying in lettering to be later inscribed with the chisel.

87

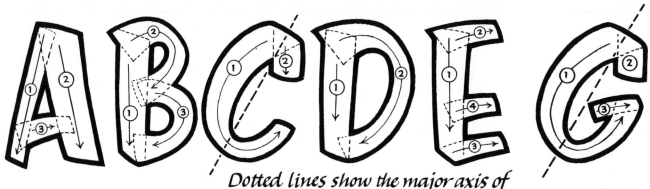

Dotted lines show the major axis of oval letters.

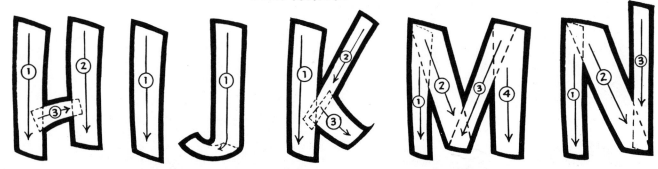

Use poster paint instead of ink for practicing these letters.

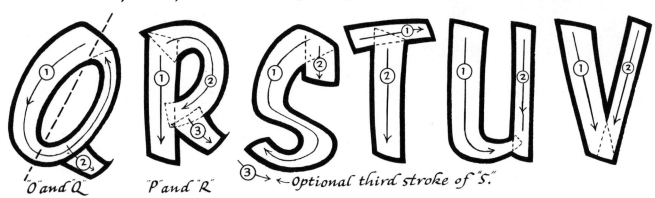

"O" and "Q" "P" and "R" ← *Optional third stroke of "S."*

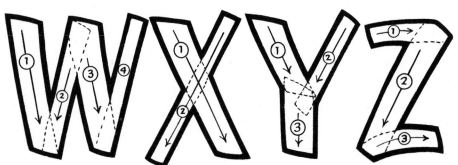

These letters can be made with a flat-edge brush or a pointed watercolor brush. The circles and arrows denote the sequence and direction of the strokes.

88

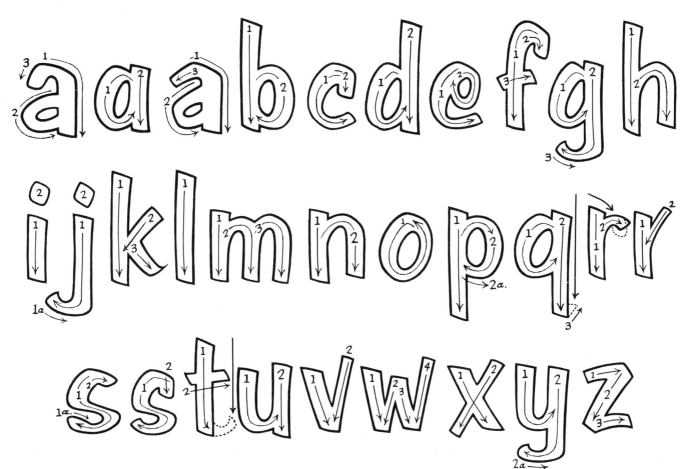

Much of the character of free-brush strokes is lost here in order to demonstrate the fundamental strokes, which are shown in sequence and direction by the numbered arrows. The outlined letters show the form and construction of the alphabet. Letters in a word should be packed tightly as in the lettering to the right. The letters can jump slightly. Try condensing and extending the forms for interesting effects.

Shown below are the numbers, which are all about the same width except for 1.

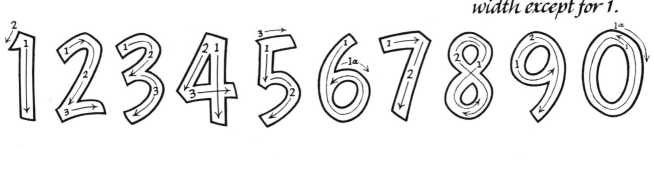

1979 Spring Collection

The lettering above was done with a flat-edge brush that turned as the letters were stroked. It was done on rough watercolor paper to simulate an artist's brushstrokes and was used as a caption on a brochure that advertised masterpieces of the product involved. The lettering was very slightly reduced.

Graduation Cards

The graduation lettering was used on a poster advertising greeting cards. It was lettered on pebbled mat board and expresses chalk lettering on a blackboard, which is appropriate for the kind of card advertised.

Brush Script

The casual brush script shown above was lettered quickly with the edge of a pointed watercolor brush and slightly retouched.

Popular Papers

The controlled script above was lettered many times with a flat-edge brush, retouched, cut apart, and reassembled to get the final finished lettering that you see here.

ABCDEFGHIJKLMNOPQRS
TUVWXYZ&abcdefghijklm
nopqrstuvwxyz fi ff ffi ffl ffi .,;-
"'"!?()1234567890$$¢%

The lettering artist often uses existing typefaces that are available for inspiration and practice to perfect his own style. The type font above is Flash, an ATF face, which can be used to practice brush lettering. There are many other good brush typefaces.

Optical Illusions

In lettering you must often compensate for visual appearance by distorting the seemingly correct proportions. The letter O is one example. If it just touches the top and bottom guidelines, it will appear to be smaller than the other letters in a word. It must extend beyond the guidelines so that it will look as if it is the same size as the other letters. Shown below are other examples.

All curved parts of letters that meet guidelines should extend beyond the guidelines. This is also true of pointed parts of letters.

On any letter that has thick and thin elements, the widest part of the curves is heavier than a stem stroke of a straight-line letter. Otherwise it will appear to be too thin.

Where strokes converge, as in the above letters, the strokes must taper slightly at the point of convergence. Otherwise the letter will look too heavy, as in the A (circle). This is particularly true of bold letters.

The center parts of the B, E, F, H, K, S, and X are slightly above the center height of letters. Otherwise the bars look too low.

The B and S top loops are larger than the bottoms.

rn m

The character of some letters requires special spacing. In the examples above the rn looks like an m. This is especially true in small letters.

il

The dot of the i to the left is too close to the bottom and looks like an l.

Erik

The thickness of the stem stroke of capitals must be slightly heavier than the thickness of the stem strokes of lowercase in the same word. Otherwise the cap's stems would look thin.

abdh

In sans-serif lowercase letters the curved parts are thinner when they meet a vertical stroke.

ELT

The horizontal strokes of sans-serif letters – where the letters look as if they are the same thickness throughout – should be slightly thinner than the vertical strokes.

MN

Diagonal strokes of letters must be thinner than vertical strokes or they will appear to be too heavy.

RR

In sans-serif letters that have parts that converge, as in the R above, the tail should start away from the vertical stroke as shown above. Otherwise a heavy spot will appear (circle).

Photo-composed Lettering

In the 1930s photographic machines for typographic composition arrived on the scene. Since then an amazing degree of clarity and speed has developed. Much if not most typographic composition is now done by this method

The alphabet on the facing page was first designed for the Typositor, a machine that sets type photographically. It was later modified for use in the Alphatype machine, a computer-assisted photo-composing machine.

There are other companies that manufacture machines that use photographic means to compose type.

I'll be glad to hold your hand till you're well.

This is an enlarged reproduction of copy set on the Alphatype machine. While the speed of composition done in this manner is a challenge to letterers, a letterer will always have to design the original alphabets !!!

The quick brown fox jumped over the lazy dogs

The Quick Brown Fox jumped over

The top line above was set on the Typositor machine and is the normal setting of the alphabet as it was designed. The bottom line is a photographic distortion of the same alphabet. This distortion is possible with settings

the operator makes on the machine. The weight of the letters is heavier and the letters are extended. Many other variations of the one alphabet are possible.

a b c d e f g h i j k l m n o p qu r s t u v w x y z

s wr r n u y rr rs en er es ev in ir is iv m ar as av th ur

us uv on or os ov br bs ss ! _ ? : ' . , ; ' -) (-

1 2 3 4 5 6 7 8 9 0 " " " . _

A B C D E F G H I J K L M N O P Q

R S T U V W X Y Z

A B C E F D G H I J K L M

N O P Q R S S T U V W X Y Z

A S S A

Shown here is a font of joining formal script designed by the author for a greeting-card company. One of the design problems concerned the joining of some letter combinations. It was solved by making the ligatures of two letters into one character so that, when the operator pushed the key, two joined characters would be exposed on the print. All the letters and combinations seen here are one-character elements. Three other versions of capitals are not not shown.

qu th rr rs un

um ur us uv

an ar am as

er em es ev

on or os om

The above letters are like one character.

Stump Letters

Stump letters were used in the early 1900s to denote geographical locations on maps. They were also used by patent-office draughtsmen and engineers. They are still occasionally used today for atmospheric maps.

The letters are extended italic Roman—squat and stumpy. They are freely sketched with a pointed pen. Large capitals were used to designate important geographical locations, while small letters were used for lesser places. Shown here are alphabets of capitals and lowercase as well as numerals. Practice them on a map of your own.

the yearning human volume of love is bound caught from the up -

Photostat of stump writing from an engraving of lettering by George Becker, Philadelphia, 1820.

IHLFETNKMAVW
XYZ14OQCGDUJPR
BS83220695577&
abcdefghijklmnopqrst
uvwxyz

Modern Roman italic and stump letters from a 1912 lettering book.

ABCDEGHIJKLMNOPQRSTUVWXYZ
abcdefghjklmnopqrstuvwxyz 12345678

Typositor alphabet, H-32

ABCDEFGHJKLMNOPQRSTUVWXYZ
abcdefghijklmnopqrstuvwxyz 12345678

Craw Modern italic, a beautiful typeface designed by Freeman Craw.

The above alphabets are shown as guides to develop your own stump letters, which should be freely sketched. The map to the left shows a common usage of stump letters 50 to 100 years ago. These letters were used by map makers and draftsmen for the most part.

Splayed Strokes

A splayed stroke makes a letter thinner toward the middle and heavier at the ends. An accented terminal is a heavy beginning or ending of a stroke. If you squint your eye to get a slightly blurred image of a Roman letter, both the above effects are suggested. The serifs of Roman letters accent the ends of some parts.

A show-card painter sometimes lifts the pressure of the brush on the card as he draws a downstroke (vertical) which results in a splayed letter. Many outstanding typefaces exploit this effect.

Old style Roman Splayed sans-serif

NRFtin

Niagara

EFG TN

ACCENTED TERMINAL

Optima Bold

BqfL79

American Uncial

gbc

The above letters show accented terminals on free script.

The typefaces to the left show splayed strokes.

E A letter with exaggerated splayed strokes.

A sign painter's vertical stroke showing a slight splayed effect, done with more or less brush pressure.

97

Design

Up to this point our concern has been with the design of letters and words. The final use of letters is in design, where other elements (illustrations, photographs, color, products, etc.) may be included. Visual design should achieve order and deal with many considerations such as balancing the parts, placing emphasis where needed, and selecting appropriate letter styles. There are other points to consider, such as how your job will be printed (light-face letters are bad for reverses or dropouts, who will see your design (old folks, children, union workers, bankers) and the budget (can you afford handlettering or should it be set in inexpensive photocomposition).

Read good contemporary graphic-art publications, local and foreign. Join a graphic-arts organization and exchange ideas with others. Visit museums and graphic arts shows. Study the graphics on TV and in books, magazines, and newspapers. In time this will help you develop a feel of order and also a style of your own.

Imagination, taste, skill, craftsmanship, and creativity are ever expanding developmental factors. Every lettering designer should exploit them and is limited only by experience and talent.

Shown on these two pages are a few tips on how you can achieve visual order.

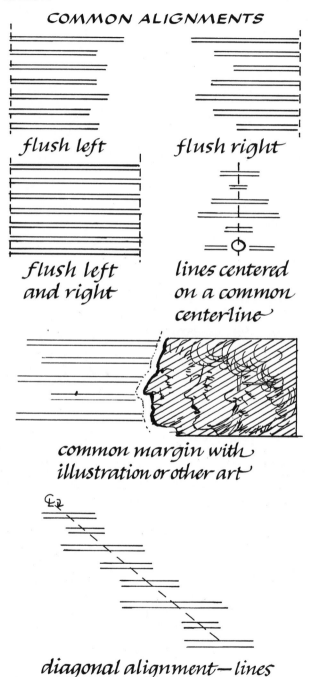

COMMON ALIGNMENTS

flush left

flush right

flush left and right

lines centered on a common centerline

common margin with illustration or other art

diagonal alignment—lines have common centerline

Space here prohibits an exhaustive discourse on design; but here are some tips that will help you organize your lettering.

All elements in your design should BALANCE either...

The greatest gift is love

YES
THERE
IS
A
SANTA
CLAUS

symetrically or asymetrically

The large cap says "start here."

ARE
YOU
AFRAID?

A contrast of size and weight helps this idea.

Variety gives interest.

THE QUICK BROWN FOX

Let your lettering breathe. It invites readership.

If you want to see your retail sales escalate, you have to reach the people with money to spend. That's why the remarkable amounts concentrated in the medium and higher-priced lines...

Old-style roman is used more than any other style for large paragraphs of text matter. It is most legible.

BIG & BOLD

ISOLATION

A design lacking emphasis has little visual appeal. Above are 2 ways of achieving it.

In any design try to line up elements.

Relationships

As a part of the design process you must be aware of the many relationships that exist in lettering. The proportions of classic Roman letters concern the relationship of height to width and of letters to each other in what has been considered the most beautiful letter style ever designed. The thickness of a vertical stroke provides a unit with which to measure letter height — the letter is so many units high.

There is always a relationship between the style of the letter and what is being said. The examples shown exhibit obviously correct choices of style.

How long should a line of lettering be in order to be easily read? This relationship must be learned. If the letter is small, the length of the line cannot be too long. This is particularly true for many lines. The caption style should be in harmony with the text type. If in doubt, make them the same.

If you have no way at all of relating style to your job, simply make the lettering legible — for that is really its main purpose.

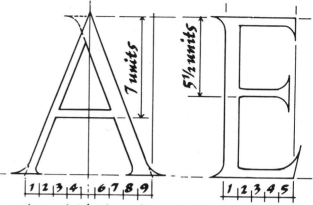

The width-height relationship (set) of a letter is one of the most important elements in learning a new style. The set of letters in relation to each other is also important. Above is shown the sets of 2 old-style letters. The relationship between the width of the stem to the height of the letter is also important and must be maintained.

íReLANO
St. John
BEN FRANKLIN
STENOGRAPHER'S HANDBOOK

The letter style should always relate to the words. The above examples are obviously good choices. Further examples are seen on page 122.

The length of the line relates to the size of the lettering. The lines you are reading are too long for the size of lettering. If this size must be maintained, it would be better to break this copy into 2 columns. Otherwise the lettering should be larger.

O P

If the letters have heavy stems and thin hairlines, they should all look the same weight. The hairlines in the P above are not the same as those in the O but should be, as well as all the other letters in the line.

K k

The thickness of the stem stroke on capitals is slightly more than that of the lower case (arrows). This relationship must be maintained or your lettering will look wrong.

There are many letters where the relationship of the style to the tool used is very obvious. These were drawn with a flat-edged tool.

PLEASE
EAT ONLY
AT THE
LUNCH
HOUR

The letter style should relate to your audience. The above is for young school children. Below is one directed to old folks, whose eyesight may be bad.

STEP UP

READ
MORE
GOOD
BOOKS

Paris
Styles

Formal lettering (old-style roman) is best for symetrically balanced layouts, while contemporary styles are more frequently used in asymetrically balanced designs.

Twisting and Turning

Earlier in this book the importance of maintaining a consistent pen angle to form many of the written styles was emphasized. While this function will alway be true in the main, some calligraphers and letterers are currently experimenting with written forms by using a technique called twisting. The flat-edged tool is greatly manipulated and turned to obtain a new look. The Rustic capitals of the 4th century required twisting and turning of the pen, and many flat-pen-written letters since then allow twisting. Some of the new alphabets are very handsome.

The y to the right was formed with twisting a pointed watercolor brush. The S above was formed by twisting a large flat-edged pen. The diagram at the top shows the position at start and finish of one stroke in each letter and shows how pen turns to form the letters.

Practice with the pens and brushes and other flat-edged tools, and, if nothing else, you will be gaining pen or brush control. Practice! Practice! Practice!

The above diagram shows how tool twists in chisel-point lettering.

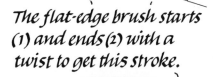

The flat-edge brush starts (1) and ends (2) with a twist to get this stroke.

Numbers

Numbers are symbols for quantities. Letters are symbols for sounds. Roman numerals were used until the 10th century, when Arabic numbers were adopted.

There are two major forms of numbers – the modern aligning type and the old-style nonaligning type. All numbers except 1 are the same width. The O is narrower than the capital O.

Punctuation marks are drawn in the same manner (weight and style) as is the alphabet to which they belong.

AB.,;:'-!?1234567890

AB 1234567890 (&.,:;!?""")

A1234567890 (&.,:;!?"""

When you design numbers and punctuation marks make them harmonize with your letter style as in the examples above, picked at random.

The letter O is always wider than the number 0 as shown above.

1234567890

The numbers above are lining (ranging or modern) – they all align between two guidelines. The numbers below are nonaligning, nonranging, or old style.

OPTIONAL

1234567890

?

The interrobang is a punctuation mark which stands for both a question mark and an exclamation.

111

NUMBER CAPITAL I LOWERCASE l

The sans-serif number one should have a half-serif at top to distinguish it from a cap I and a lowercase l.

103

Outline and Bold Letters

Suppose that the boss wants an outline letter from an alphabet that does not include an outline in its family of fonts. Here is a method of making an outline letter from any black-and-white alphabet.

Enlarge the black-and-white alphabet that you have to a convenient working size on an opaque negative photostat. Paint white around the letters, leaving a thin black edge as shown. Retouch if necessary with opaque white paint. Reduce the alphabet to the desired size. The original outside letter edge is the inside white edge of the outline letter, which is as it should be.

All letters of the alphabet will be treated like the sample letter A below.

This is the original letter. It should be enlarged to a convenient-size <u>negative</u> print.

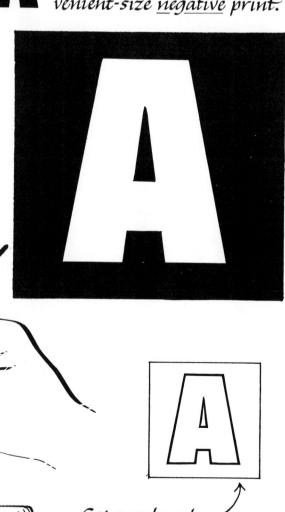

Your outline letter

WHITE OPAQUE Paint

Get a reduced print of final art for your alphabet. Make a master sheet as on page 119.

To make a bolder version of the letter on page 104, simply fill in the outline letter. Retouch with white opaque paint if necessary.

Get extra prints of the letters and make a master alphabet as on page 119.

The letters below show a comparison of the original letter, the outline letter, and the bolder version.

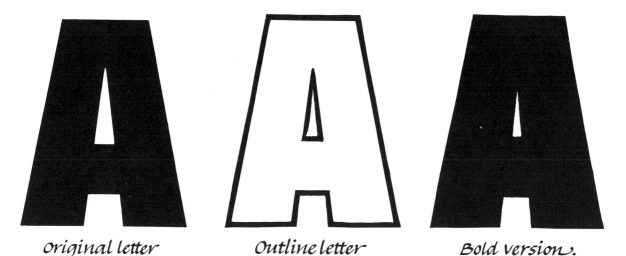

Original letter *Outline letter* *Bold version.*

Charts and Graphs

You may be called on to make charts and graphs for sales meetings, conventions, and the like. Here are some special tools and layout suggestions that you might use to advantage.

1. Keep charts simple and easy to read. Do not clutter them with too much information.
2. Most charts must and can be done quickly by using simple letterforms.
3. Charts should look spontaneous—no overworked fussy lettering.
4. Photostat complicated logos, ads, and details, cut the stat on the image edges, paste onto the chart, and color if necessary.
5. Allow a white border or mat of space around the entire chart—do not letter from edge to edge.

Calligraphic
Bookhand
BRUSH

Because they can be drawn quickly and are easily read use simple letterforms like the above.

COIT PEN **FELT NIB**

These are wide flat-edge tools for large, simple letters.

Allow a border of space around all sides.

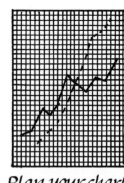

Plan your chart on graph paper—then enlarge it.

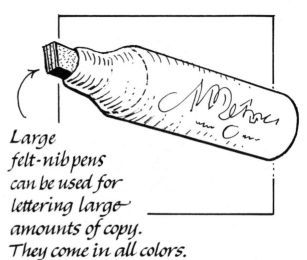

Large felt-nib pens can be used for lettering large amounts of copy. They come in all colors.

Here are some of the most frequently used chart layouts.

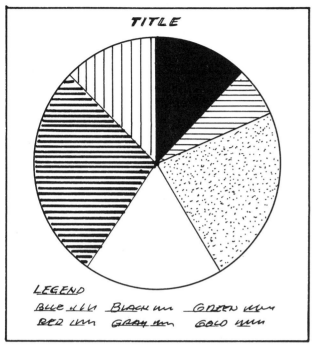

TITLE

LEGEND

BLUE //// BLACK //// GREEN ////
RED //// GRAY //// GOLD ////

PIE

WHY IS JONES #2?

SO... LET'S GO

Use simple large letters for emphasis.

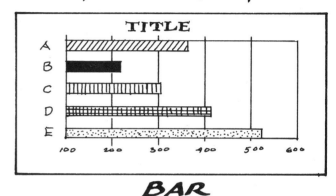

TITLE

A
B
C
D
E

100 200 300 400 500 600

BAR

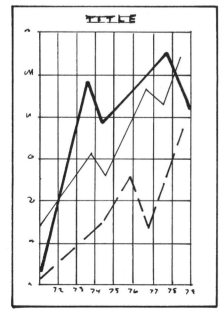

TITLE

72 73 74 75 76 77 78 79

LINE

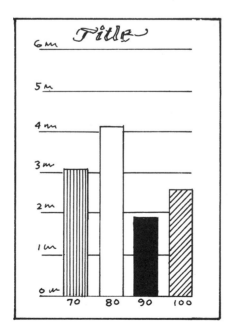

Title

6 M
5 M
4 M
3 M
2 M
1 M
0 M

70 80 90 100

COLUMN...

HERE COME THE GALS

1980 1981 1976 1976

A variation of column chart when illustrations are used instead of columns.

Swash Letters

A letter designer will sometimes add a decorative touch called a swash. It is a flourished extension of a part of a letter. Many typeface fonts now include them. They usually appear at the beginning or ending of a line; a descender sometimes extends into space at the bottom.

In black letter swashes were called flags. Use them sparingly. Avoid using them in the middle of a word—unless the word is a logotype or trademark for which some distinctive effect is desired. Extra swashes can be added to formal script, which is naturally decorative.

An exaggerated swash initial
Nuremberg, 1601

The beginning and the end and everything else

Many typefaces include swash letters in their fonts.

D D

You can make your own swash letters by simply adding a swash to some part of a letter (type).

FOR YOU DEAR CHILDREN ON YOUR ANNIVERSARY

An interesting use of swashes on a greeting-card caption.

Letter Fitting

Fitting letters into a required space is always a problem. The best way is to letter your job carefully and to project it up or down on an enlarging machine (Lucy) if you have one. Another way is to photostat it up or down to fit. If you have no mechanical aids, draw guidelines and letter your job lightly in pencil. If the letters do not fit, erase and try again until they do. Still another method is to establish points on the edges of your lettering, to project them to another piece with the aid of parallel lines, as shown, and to finish the lettering.

HOME

Suppose you want to enlarge HOME to the width of AB.

First draw line AC at any angle to AB. DE is the base line of the letters. Draw a line through C and B. All lines (dotted) projected from points on AC to AB are parallel to CB. These lines intersect AB and establish points, and when perpendicular lines are drawn through these points they establish the limits of the areas of the enlarged letters. The new height BF is obtained from CE by the construction shown above. C and B are the centers of proportionate quadrants and will establish the height of the enlarged letters. This method of enlarging (or reducing) a word exploits the old principle of similar triangles.

109

Permanent Guidelines

In writing calligraphy or designing slanted letters you may find the suggestion shown below helpful. On paper or thin card draw guidelines with black ink. Repeat as often as desired. On a piece of acetate draw parallel lines about ½" apart. Line up the first card with a T-square and secure it to your drawing board. Over it attach the acetate at any slant you want. Over both pieces attach translucent paper and proceed with your lettering. If the material is more opaque, use a light table or a convenient-sized piece of heavy plate glass with the edges taped and a light underneath. Use it like a drawing board.

Hammermill duplicator paper is good for this method, relatively inexpensive and permeable to ink. One advantage of this method is that you have no messy guidelines to erase when finished.

Guidelines drawn on thin card

Parallel ink lines drawn on acetate

Acetate overlaying guidelines

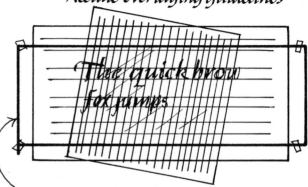

Vellum (heavy line) overlays entire setup...

Graph paper... ...with acetate overlay

Textured Lettering

Many textures and special effects can be applied over lettering to bring out the meaning of the words. Shown below are some samples. Inexpensive film screens and textures can be laminated over the lettering and unwanted parts cut away. You can letter on tracing paper laid over a variety of textured surfaces (leather, flat stone, pebbled mat board, for example). The printer can supply a variety of screened tints and textures to use on lettering when he makes the plates for printing.

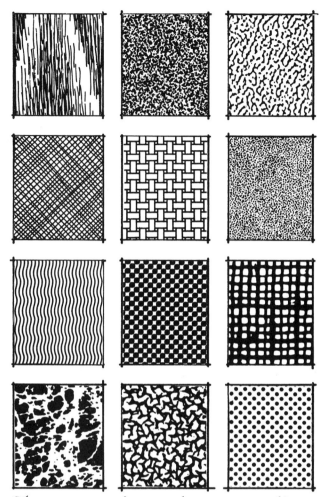

The outline letter was drawn and the transfer texture sheet was adhered over it. Unwanted parts were cut away, leaving the letter with the texture inside.

The lettering above was done with a grease pencil on tracing paper laid over a piece of leather.

The textures shown above are available in art stores to be used as in the example to the left. Some patterns are dry-transferred instead of laminated.

The lettering at the bottom was drawn on tracing paper laid over a piece of pebbled mat board. It was printed in light gray ink on a lighter gray paper and used on a letterhead.

Curved Effects

Here are a few examples of curved lettering.

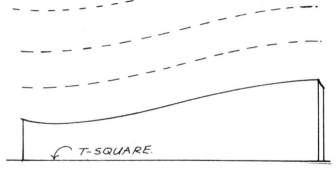

Draw your curve on a piece of heavy cardboard and cut a template (shaded part). Smooth the edge with sand- paper and use the template against a T-square. Repeat the curves as desired (dotted lines).

Wrinkle your lettering, attach it to a piece of cardboard, and photo- graph or photostat it. Retouch the print afterward.

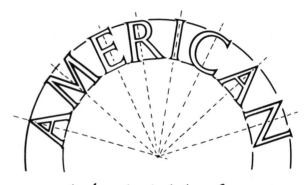

Draw circles the height of your letters. Sketch centerlines for all letters (dotted lines). Draw or paste down your lettering with the centerline of the letter corresponding to a dotted line that passes through the center of the circle.

Lettering can be attached to a can or tube, then tilted and photographed. The print is retouched later. Experiment with different angles, sighting through the camera until you get the effect you want before photographing it.

Monograms, Ligatures, Logotypes, *and* Trademarks

These designs usually combine two or more letters with a common element. They are used to identify people or companies. A knowledge of design and letterforms is required for effective arrangement. The letters should be in the same style and should relate to the person or company – reflect the personality or product. Simplicity and legibility are absolute requirements. An object can be substituted for a letter, or a letter can be shaped to an object. Letters can be reversed or enclosed in a shape. Uncial letters are often suitable. Cut letters and shapes from colored paper and move them around. Design one for yourself.

Norwegian Caribbean Lines®

Instituto Nacional de Industria
MADRID, SPAIN

Institute of Contemporary Art
LONDON

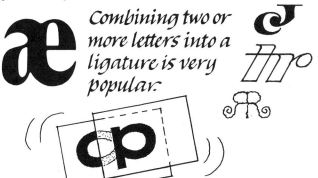

Combining two or more letters into a ligature is very popular.

An excellent way of getting a monogram or logotype is to design one letter on each of two transparent pieces (film, tracing paper, etc.) and move them around over each other until you get an interesting effect.

The three logotypes above are outstanding examples of good identifying symbols. The Norwegian design expresses the sea with a wave effect.

The Siwash Society of Scribes (ficticious) exploits the flat-edge pen held at a 45°angle for a calligraphic society.

Contemporary Styles

Much of the English alphabet is not perfect. It is not really suited to the language. The visual symbols have weaknesses. For example, the capital letters O and Q, V and Y, and G and C are similar; lowercase sans-serif i next to n looks like m. Instead of uppercase and lowercase Bradbury Thompson encouraged the use of one 26-character alphabet based on the better of each of the present large and small letters.

It has been proven that lowercase Roman text types are best for large amounts of copy (as in books). Larger display styles offer much more variety of form. Shown here are some very popular contemporary styles. Some may remain; others will be redesigned and will eventually become what is termed contemporary. The letterer must be aware of these styles and design around them. To interpret the spirit of the present times in new letterforms should be the objective of every creative letter designer.

Some authorities are dismayed by the large number of distorted styles in use today and predict another revival of the classic style. This has happened periodically in the past.

ΛBCDEFGHIJKL
MNOPQRSTUVW
XYZ123456789

Experimental alphabet by R. G. Miller, N.Y.

ABCDEFGHIJKLM
NOPQRSTUVWXYZ

A one-character 26-letter alphabet has many advantages too numerous to mention here.

TARAS BULBA

Lettering for a motion picture where an ethnic (Russian) character was desired. The serifs suggest russian characters.

Lettering today is twisted, double-outlined, shaded, distorted with decoration such as the sample above. Observe some of the T-shirt examples.

Shown below are samples of contemporary letter styles. There are many others; space prohibits showing them. Complete fonts of these display alphabets are not shown for the same reason. The capitals only are shown to exhibit the general characteristics. In a short time there will be new stylings. Some of the current styles may remain.

ANTIQUE OLIVE BOLD

ABCDEFGHIJKLMNOPQRSTUVWXYZ

MACHINE

ABCDEFGHIJKLMNOPQRSTUVWXYZ

SOUVENIR MEDIUM

ABCDEFGHIJKLMNOPQRSTUVWXYZ

MOTTER OMBRA

ABCDEFGHIJKLMNOPQRSTUVWXYZ

SERIF GOTHIC BOLD

ABCDEEFGHIJKLLMNOPQRSTUVWXYZ

AVANT GARDE GOTHIC MEDIUM

AAABCDEFGHIJKLMMNOPQRSTUVVWWXYZCACEAFARGA

DATA 70

ABCDEFGHIJKLMNOPQRSTUVWXYZ

Other popular faces, such as Futura, Palatino, Optima, Caslon and Helvetica, are shown in other pages in this book. The above styles have many weights and sizes, but we cannot show them all here. The letters, in composition, are most often packed (tight spacing).

Condensing and Extending

Shown here are three letters, all in the same style. The first is the regular form as it was originally designed. The second is the condensed version. Its width is narrower than that of the first, but its height is the same. The third is an extended version. Its width is wider than that of the first, but the height is the same.

These descriptions refer to one letter of an alphabet style. In any alphabet some letters are wider and some narrower than others in the regular form. W and M are wide, B, E, F, L, P, and S are narrow. When all the letters of an alphabet are condensed, the wide letters become much narrower than normal. The narrow letters become slightly less wide than in the normal form. The regular relationship among all letters always remains the same but not to the same degree in condensed or extended versions. In other words, a W will never be narrower than an E, even if condensed. For extended versions of an alphabet the reverse is true. The narrow letters become proportionally much wider than do the wide letters. This may be a bit confusing, but it is a good idea to keep these relationships in mind when you design extended or condensed versions of your original alphabet.

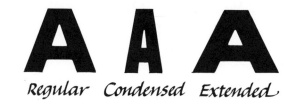

Regular Condensed Extended

Venus Bold
abcdefghijklmnopqrstu
ABCDEFGHIJKLMNOP

Venus Bold Condensed
abcdefghijklmnopqrstuvwxyz
ABCDEFGHIJKLMNOPQRSTUVWXYZ

Venus Bold Extended
abcdefghijklmn
ABCDEFGHIJKL

The three samples above show letters which are all the same style (Venus), same size (from top to bottom, they are all the same height), and the same weight (bold). They also show the great variety possible in condensed and extended letters. At a glance they almost look like different styles.

Note that in condensed and extended versions, the widths of the letters (especially capitals) tend to look the same.

Temporary Guidelines

When you have a large amount of copy to letter — in calligraphy, for example — here is a quick way to obtain guidelines. On the back of your vellum paper draw lines the thickness of the flat edge of your chisel-point pencil. The width of your pencil will be the x height of the small letters. Carefully measure the spacing between the lines and repeat these lines down the paper. Turn the paper over, and you can see the x height of your lettering. Letter your job. When finished, turn the paper over again and erase the pencil lines from the back.

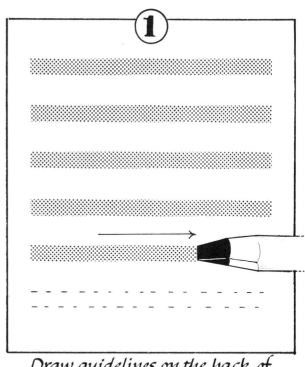

Draw guidelines on the back of tracing paper or vellum

letter your job and erase the pencil lines from the back.

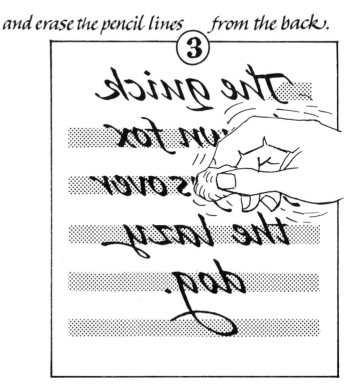

Make Your Own Paste-down Lettering Sheets

You can purchase alphabets that are printed on transparent sheets with adhesive on the back and a loose paper to back them up. The letters are cut out one at a time when composing your job.

You can design your own alphabet and arrange the letters with repeats on a master sheet if you have a photostat machine or service handy. If you get stats of the letters for repeats from the master sheet, the cost is negligible when you consider the money that you will save later. After you make up a master sheet, you can enlarge, reduce, or shoot same-size and get a positive photostat print. This print can be waxed or coated with rubber cement on the backside. Backs of old tracing pads (sprayed with varnish fixative) can be used as a cutting board. Sheets can be stored for future use by putting a piece of wax paper on the adhesive side. (do not cut up your master sheet — keep it for shooting only.) Your alphabets are used in the same manner as are the purchased ones, except that you are using a print instead of thin film to compose your job.

ABCDEF
GHIJKLM
NOPQRS
TUVWXY
Z AELM
N&S, .?!
, " " _ _

Original handlettered alphabet

Duplicate photo prints of the original lettering above.

~'76~

A A A A A B B B C C C
D D D D E E E E E F F F
G G H H H H H I I I I I J J K
K L L L L M M M N N N
N N O O O O O O P P P Q
Q R R R R R R S S S S S T T
T T T U U U U U V V V W W
W X X Y Y Y Z Z *A A*
E E L L M M N N & &
S S , , . . ? ? ! ! " " " " — — — —

POSITION	LETTER
1	E
2	T
3	A
4	O
5	N
6	R
7	I
8	S
9	H
10	D
11	L
12	U
13	C
14	M
15	F
16	G
17	Y
18	P
19	W
20	B
21	V
22	K
23	X
24	J
25	Q
26	Z

Above is the completed master sheet. Never cut it up. It has extra letters according to the frequency chart to the right of this page. A complete alphabet would include small letters, numbers, and additional punctuation marks. From this master, you order stats, larger or smaller, and compose your job.

The letters repeating most often in average text listed here according to frequency.

Cleaning Pens and Brushes

Never put a pen that you have just used on your drawing board or taboret without first dipping the pen nib in water and drying with a wipe rag. Small pieces of blotter can be cut and used to clean your pen. If you use a fountain pen with a straightedge, clean it every week by flushing with warm water, dry, and refill with fresh ink. Large pens can be cleaned by flushing them under running warm water.

Never put a brush down without rinsing it in the water jar, semicleaning, and drying by squeezing the hairs between your fingers. Thoroughly clean brushes when you are finished using them.

Do not use hot water to clean brushes: it will shorten their lives. Try not to use ink in brushes. If you must, clean them thoroughly after use with soap and warm water.

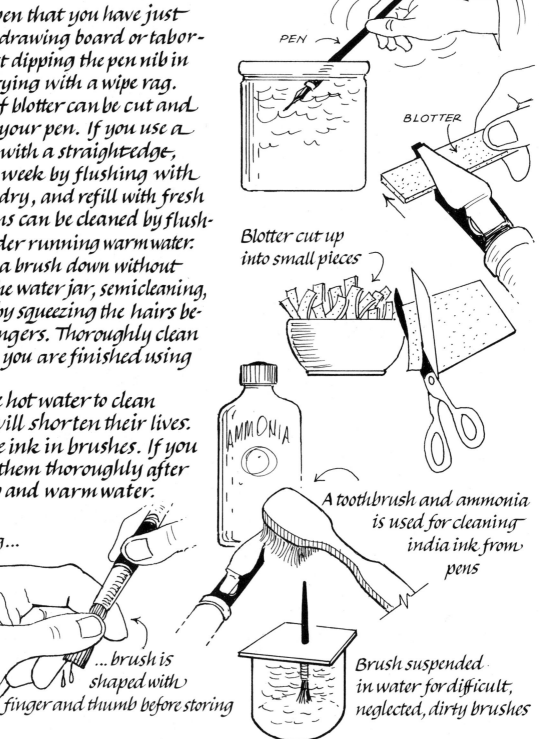

PEN

BLOTTER

Blotter cut up into small pieces

AMMONIA

A toothbrush and ammonia is used for cleaning india ink from pens

After cleaning...

...brush is shaped with finger and thumb before storing

Brush suspended in water for difficult, neglected, dirty brushes

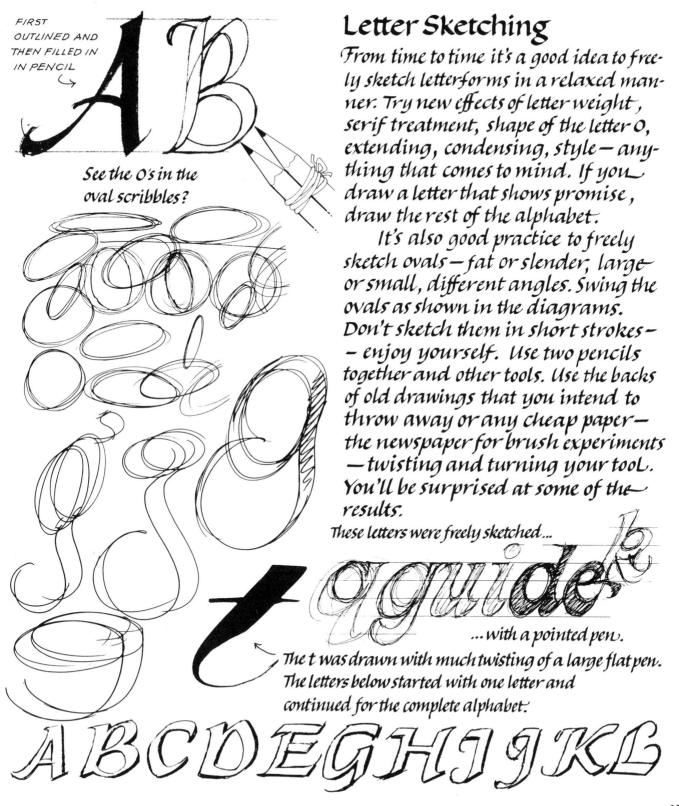

FIRST OUTLINED AND THEN FILLED IN IN PENCIL →

See the O's in the oval scribbles?

Letter Sketching

From time to time it's a good idea to freely sketch letterforms in a relaxed manner. Try new effects of letter weight, serif treatment, shape of the letter O, extending, condensing, style — anything that comes to mind. If you draw a letter that shows promise, draw the rest of the alphabet.

It's also good practice to freely sketch ovals — fat or slender, large or small, different angles. Swing the ovals as shown in the diagrams. Don't sketch them in short strokes — enjoy yourself. Use two pencils together and other tools. Use the backs of old drawings that you intend to throw away or any cheap paper — the newspaper for brush experiments — twisting and turning your tool. You'll be surprised at some of the results.

These letters were freely sketched...

a guide

...with a pointed pen.

The t was drawn with much twisting of a large flat pen. The letters below started with one letter and continued for the complete alphabet.

ABCDEGHIJKL

What Letter Styles Express

All letter styles have a personality and a commonly accepted use. An old-style Roman capital is used to convey a classic, architectural, inscriptional, conservative, or proprietary feeling. It is a traditional style for book titles.

The choice of an appropriate style depends on its use in your design. The surface of the material on which it will be printed is important. If your lettering is to be printed on rough paper, the style should be bold. The arrangement is also important. Conservative lettering should be symmetrically balanced. The style can relate to your design by tying in with other elements such as color, illustration style, historical reference, or borders.

ST. PATRICK'S DAY

The Pottsville News

Learn to Dance

NO SMOKING

JULIUS CAESAR HIS LIFE AND TIMES

In addition to old-style Roman shown above other major styles can express the following:

Uncial — sincerity, the ecclesiastic, monograms, Ireland

Blackletter — religion, dignity, Middle Ages, Germany, publishing

Formal script — grace, colonialism, personality, caprice.

Roman lowercase — legibility (not as formal as capitals)

Sans Serif — boldness, simplicity, the contemporary

Novelty can be expressed with frivolous distortions and decorative effects. Boldness expresses emphasis; antique effects express age.

Shown here are a few examples of how the lettering style gives meaning to the words it composes. Always try to enhance the meaning of words by choosing appropriate letter styles for them.

SELLS & BAILEY
CIRCUS

This square-serif letter has always been linked to the circus and entertainment.

AUBREY
BEARDSLEY

An art nouveau style is used here for one of its proponents.

ROARING
TWENTIES

This style was very popular during the 20's and so is a good choice for these words.

You're nice as they come!

Informal script denotes something personal. It is frequently used on greeting cards.

AMERICAN
ANTIQUES

Rough edges and old-style Roman are perfect for these words.

Certificate
Awarded to _____

Blackletter and formal calligraphy have been used traditionally for certificates and diplomas.

TOO FAT?
diet and reduce

The styles speak for themselves.

fast relief

Slanted brush lettering suggests speed.

Working Method

Here is a system of working step-by-step from start to finish that you should find helpful in solving your lettering problems.

Be certain that you understand the problem. If you do not, ask questions. Select a style and make small proportional sketches (thumbnails). When you are satisfied with a solution, make a full size sketch (rough layout). Check the method of reproduction and the kind of paper that your work will be printed on. Be sure that your boss or client okays your rough. Proceed with your finished lettering. The sketch can be enlarged to a convenient working size and reduced later for the mechanical. Check your lettering. Do all the letters slant in the same direction or are they all perfectly vertical? Are all the weights the same? Is the spacing perfect? Are you completely satisfied that this is the best that you can do? The answers to all these questions should be "yes."

Thumbnail rough sketches

Enlarged comprehensive layout to the printed size.

After the layout is okayed, the finished lettering is done and sent to the studio where a mechanical paste-up is made with all the other elements and then sent to the printer.

Finished lettering

Backword

The real authors of this book are the pre-Christian Greeks, the Roman artisans who carved the lapidary capitals (especially those on the Trajan column), Charlemagne, medieval monks, Irish scribes, Arrighi, Gutenberg, the typeface designers (Jenson, Garamond, Baskerville, Caslon, Bodoni, Renner, and Zapf) and many other letter designers. You should study the historical development of styles. For further reading consult the books listed in the bibliography.

My part was to show how these letters were designed — primarily by exploiting the tool used to form them. Finished lettering cannot be taught in a book. How well you render finished lettering is a matter of time and practice. Understanding how letters are formed and modifying them are also creative. With an active imagination and much practice you may create a new style.

Acknowledgments

When writing a book of this nature the total effort is rarely the work of one person. Therefore I salute the old writing masters in the scriptoria, the calligraphers and letterers past and present, the designers of the classic typefaces from Nicolas Jenson to Herman Zapf, and others for their rich heritage in understanding letterforms today and for giving the author much source material for writing this book.

I also acknowledge the friendly cooperation of others who have helped. They are listed below. My effort would have been much more burdensome without their assistance. I tip my hat to Ed Rondthaler of Photolettering Inc., to Wendy Lochner, my editor, to Susan Short who helped with typing, to lettering artists Dave Davison, Herb Wiley, Hal Kobak, and Denis Williamson for borrowing their lettering, and to Sandi Gabriel, Cheryl Gibbs, and Vicki Kripaitis who helped with odds and ends.

Bibliography

John Howard Benson and Arthur G. Carey
THE ELEMENTS OF LETTERING
John Stevens, Newport, RI

George Bickham
THE UNIVERSAL PENMAN
Dover Publications, INC., New York, NY

Warren Chapell
THE ANATOMY OF LETTERING
Loring and Mussey, N.Y.

Carl Dair
DESIGN WITH TYPE
University of Toronto Press, Toronto

Edward Johnston
WRITING ILLUMINATING and LETTERING
Sir Isaac Putnam & Sons, Ltd., London

Oscar Ogg
AN ALPHABET SOURCE BOOK
Harper and Row, N.Y.

Jacqueline Svaren
WRITTEN LETTERS: 22 Alphabets for Calligraphers
The Bond Wheelwright Co., Freeport, Maine

Daniel Berkley Updike
PRINTING TYPES, THEIR HISTORY, FORMS and USE
Harvard University Press, Cambridge, MA

Publications: CA (Communication Art), American Artist
Art Direction, U/lc (Upper and Lower Case)

Lists of excellent lettering and related books can be secured by writing to:
Pentalic Corporation, 132 West 22nd Street, New York 10011
Dover Publications, INC., 180 Varick Street, New York 10014

Index